A–Z
OF
NEWCASTLE
PLACES – PEOPLE – HISTORY

Ken Hutchinson

Acknowledgements

I would like to thank all the staff at Amberley Publishing and Newcastle City Guides for their information, advice and help over the years. Thanks go also to Sarah Mulligan and staff at Newcastle Libraries for the use of pictures from their collection. Thanks again to my wife Pauline for proofreading the book and to my family for their continued support, especially my sons Peter and David, daughter-in-law Sue and granddaughter Isla.

All royalties from the book will be donated to and shared by St Oswald's Hospice and the Sir Bobby Robson Foundation.

To all Geordies past and present

First published 2018

Amberley Publishing
The Hill, Stroud, Gloucestershire, GL5 4EP
www.amberley-books.com

Copyright © Ken Hutchinson, 2018

The right of Ken Hutchinson to be identified as the Author of this work has been asserted in accordance with the Copyrights, Designs and Patents Act 1988.

ISBN 978 1 4456 6508 5 (print)
ISBN 978 1 4456 6509 2 (ebook)

All rights reserved. No part of this book may be reprinted or reproduced or utilised in any form or by any electronic, mechanical or other means, now known or hereafter invented, including photocopying and recording, or in any information storage or retrieval system, without the permission in writing from the Publishers.

British Library Cataloguing in Publication Data.
A catalogue record for this book is available from the British Library.

Origination by Amberley Publishing.
Printed in Great Britain.

Contents

Introduction	6	Clasper, Harry	21
		Clayton, John	22
Allan, Dame	7	Collingwood, Admiral	
Almond, David	7	Lord Cuthbert	22
All Saints' Church	7	Collinwood Bruce, John	23
Animals, The	8	Cook, Jason	23
Angel of the North	8	Cookson, Dame Catherine	23
Ant and Dec	8	Corvan, Ned	23
Ameobi, Shola	8	Cowen, Joseph, MP	23
Arena	8	Cram, Steve	24
Armstrong, Lord William	9	*Crocodile Shoes*	24
Assembly Rooms	10	Crown Posada	24
Atkinson, Rowan	10	Cycle Hub and C2C	24
Auf Wiedersehen, Pet	10		
Avison, Charles	10	Darling, Julia	25
		Dean Street	25
Bainbridge's	11	Diamonds Speedway	25
Balmbras	11	Discovery Museum	25
Barbour, Dame Margaret	11	Dobson, John	26
Baltic	11	Dog Leap Stairs	26
Beardsley, Peter	11	Douglas Frederick	26
Bell, Gertrude	12		
Bell, Sir Isaac Lowthian	12	Eagles	27
Bell Scott, William	12	Edwards, Jonathan	27
Bessie Surtees House	12	Eldon Square and Lord Eldon	27
Bewick, Thomas	13	Eldon Square Shopping Centre	27
Bigg Market	14	Emerson Chambers	27
Blackett Street	14	Exhibition Park	28
Blackfriars	14		
Black Gate	15	Falcons	29
Blacksmith's Needle	16	Fenwick	29
Bolam, James	16	Fire, 1854	29
Buddle, John	16	Fish Market	29
Burn, Sir John	17	Flood, 1771	30
Burt, Thomas	17	Foster, Brendan	30
Byker Grove	17	Freeman Hospital	30
Byker Wall	17		
		Gallowgate	31
Carmichael, James Wilson	18	Garibaldi, Giuseppe	31
Castle	18	Gascoigne, Paul	31
Central Arcade	19	Gate	31
Central Station	19	*Geordie Shore*	31
Chambers, Robert	19	*George Gently*	32
Charlton, Jack	20	Georgian Bridge	32
Chaplin, Sid	20	*Get Carter*	32
City Hall	20	*Goal*	33
China Town and Chinese Arch	20	Gosforth Park	33
Civic Centre	21	Grainger Market	33
Clark, George	21	Grainger, Richard	33

Great Exhibition of the North	34	Lindisfarne	50
Great North Museum: Hancock	34	Literary and Philosophical Society	50
Great North Run	35	Live Theatre	50
Great Siege, 1644	35		
Green, Robson	35	Mcleod, Mike	51
Grey's Monument, Charles Grey	35	Macdonald, Malcolm	51
Grundy, John	36	Mcelderry, Joe	51
Guildhall	36	Mckinnell, Catherine, MP for Newcastle North	51
		McCracken, Esther	51
Hadaway, Tom	37	Malia, Carol	52
Hadrian's Wall	37	*Man with Potential Selves*	52
Hadrian's Way	38	Marks & Spencer Penny Bazaar	52
Hair, Thomas Harrison	38	Marley, Sir John	53
Halfpenny, Jill	38	Medieval Bridge	53
Hall, Sir John	39	Metro	54
Hall, Lee	39	Metro Centre	54
Hardwick, Charlie	39	Milburn, Jackie	54
Harvey, Joe	39	Millennium Bridge, Gateshead	54
Hatton Gallery	39	Miller, Stephen	55
Healy, Brendan	39	Millican, Sarah	55
Healy, Tim	40	Monkchester	55
Higgs, Professor Peter	40	Moot Hall	56
High Level Bridge	40	Mosley Street	56
Holland, Jules	41		
Hoppings, Town Moor	41	Nail, Jimmy	57
Holy Jesus Hospital	41	Neville, Mike	57
Hume, Basil	42	Neville Street	57
		Newcastle Breweries and Brown Ale	57
Infirmary	43	Newcastle Coast	57
Institute of Mining and Mechanical Engineers	44	Newgate Street	58
Ingham, Robert	44	Noble, Ross	58
International Airport	44	Northern Stage	58
		Northumberland Street	58
Javel Groupe	45		
Jesmond Old Cemetery	45	O2 Academy	59
Johnson, Brian	45	Old George	59
		Olusoga, David	59
Kevin Keegan	46	Onwurah Chi, MP for Newcastle Central	59
Keelman's Hospital	46	Ouseburn	59
King Charles I	47	Oxford Galleries	60
King Edward VII Bridge	47		
King, Martin Luther	48	Parsons, Sir Charles	61
Knopfler, Mark	48	Pilgrim Street and Gate	62
		Pons Aelius	62
La Frenais, Ian, and Dick Clements	49	Port of Tyne	63
Laing Art Gallery	49	Purvis, Billy	63
Library	49		
Life	50		

Quayside	64	Thornton, Roger	82
Queen Elizabeth II Bridge	65	Thunder Rugby League Club	82
		Town Walls	82
Racecourse	66	Town Moor	83
Ramsey, Chris	66	Trinity House	83
Redheugh Bridge	66	Tuxedo Princess	84
Renforth, James	66	Tyne Bridge	84
Response	66	Tyne God	85
Ridley, Geordie	67	Tyne Theatre and Opera House	85
River God	67		
Robson, Sir Bobby	68	Union Rooms	86
Rocket	68	Universities	87
Royal Victoria Infirmary	69		
Rutherford, Dr John Hunter	69	Vampire Rabbit	88
		Vejjajiva, Abhisit	88
St Andrew's Church	70	*Vera*	89
St James' Park Stadium	70	Vermont Hotel	89
St John the Baptist Church	71	Victoria Statues	89
St Mary's Cathedral	72	Victoria Tunnel	90
St Mary's Church, Gateshead	72	*Viz*	90
St Nicholas' Cathedral	72	Victory, South Africa Memorial	90
St Oswald's Hospice	73		
St Thomas the Martyr Church	73	Waddle, Chris	91
Sage	74	Waugh, Ed	91
Sandgate	74	Welch, Denise	91
Sandhill	74	Wesley John	91
Science Central (Helix)	74	Westall, Robert	92
Scott, Sir Ridley	74	Westgate	92
Seven Stories	74	Westgate Road	92
Segedunum	75	Whately, Kevin	92
Shearer, Alan	75	Willington Waggonway	93
Side	76	Wilson, Joe	93
Shukla, Hari	76	Windows	93
Skipsey, Joseph	76	Wylie Graham Foundation	93
Smith, T. Dan	77		
Spedding, Charlie	77	*X Factor*	94
Spender	78	Xisco (Francisco Jiminez Tejada)	94
Stadium	78	Xander	94
Stephenson, George	78	X Marks the Spot	
Stephenson, Robert	79	(Theatre Royal)	94
Sting	79		
Swan, Sir Joseph Wilson	79		
Swing Bridge	80	Yates	95
Swirle Pavilion	80	YMCA	95
Ternan, Nellie	81	Zamyatin, Yevgeni	96
Theatre Royal	81	Zoology Degree,	
Thompson Bobby	82	Newcastle University	96
Thompson, Tanni Grey	82	Zoo	96

Introduction

Newcastle was named as the best place to visit in the world in 2018 by Rough Guides, the year of it hosting the Great Exhibition of the North. The city is famous for its history, architecture, shopping, nightlife and the friendliness of its people, known as 'Geordies'. People with links to Newcastle are famous throughout the world and include the railway pioneers George and Robert Stephenson, the inventor of the light bulb Joseph Swan, the 'King of Coal' John Buddle and the inventor of the steam turbine Charles Parsons. In sport Alan Shearer, Paul Gascoigne, Steve Cram, Jonathan Edwards, Tanni Grey Thompson and Stephen Miller all have links with the 'Toon'. In the music and entertainment business Ant and Dec, Cheryl Cole, Mark Knopfler, Sting, The Animals and Lindisfarne all started life on the banks of the Tyne. The cult film *Get Carter* was filmed here, as was *Byker Grove*, and *Geordie Shore* still is.

Newcastle was first known as Pons Aelius when it was occupied by the Romans from AD 122 to 410. The town was known as Monkchester in the Dark Ages. The Normans built an early castle in 1080 that was replaced by a stone 'New castle' in 1178 by Henry II, thus giving the town its name. The town continued to prosper through trade in wool and coal then industry. It became a city in 1882 to reflect its status as the regional capital.

In recent years Newcastle and Gateshead have worked closely together to develop the riverside area and the Newcastle Gateshead Initiative (NGI) is an organisation set up to deliver projects and initiatives on both sides of the river, and the Newcastle City Guides operate through NGI. This book therefore includes some buildings, monuments and people that are situated in or are associated with Gateshead and Tyneside.

When asked to write this book the main challenge was to try to fit everything into the space available as Newcastle has a vast number of important buildings, streets and landmarks. Many sculptures and plaques record links with numerous important people over time including kings, queens, inventors, engineers, architects, sporting heroes, entertainers, TV stars, rock stars, reality stars and even a vampire rabbit. A lot of excellent books on Newcastle have been published over the years and this one will hopefully encourage readers to delve deeper into some of the names and places listed here to find out more information about this fascinating city. Another requirement was to include at least one entry for each letter of the alphabet, which I have achieved (just), but some letters have a lot more entries than others. As with any book I apologise in advance for missing out people and places that others would have included as well as for any errors made in the information given as I have been unable to check every original source.

I am a Newcastle City Guide who has lived and worked in the North East all my life. This is my fourth book on Newcastle; my three previous books have also been published by Amberley and include *Lost Newcastle in Colour* (2014), *Secret Newcastle* (2015) and *Newcastle History Tour* (2017).

A

Allan, Dame

Dame Allan School was founded in 1705 for forty poor boys and twenty poor girls. It is now sited in Fenham but previously occupied the ornate building to the east of the City Hall, now part of the Northumbria University but built for the school in 1883. A statue to Dame Allan is still evident on a side wall. She made her money in tobacco and she lived in a large house on Wallsend Green. She sold her estate to fund the school.

Almond, David

The author of the award-winning children's book *Skellig* was born in Newcastle, went to Newcastle Polytechnic, taught in the city and still lives there. He has written many children's books, some involving local places, and a number have been nominated for various awards.

All Saints' Church

This eighteenth-century church was built on the site of an earlier medieval church known as All Hallows. David Stephenson, the prominent Newcastle architect and mentor to John Dobson, designed the impressive elliptical-shaped church with a towering 200-foot steeple. The church was opened in 1796. All Hallows was one of the original four parish churches serving the poorer Pandon and Sandgate areas.

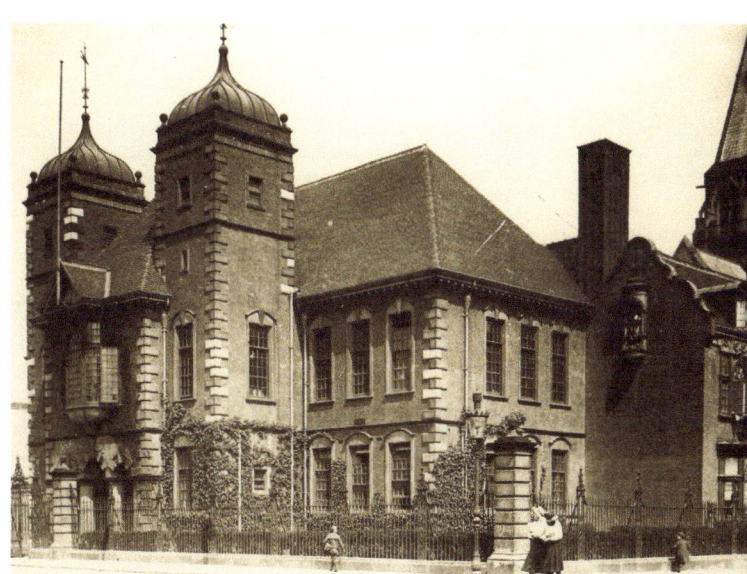

Former Dame Allan School, College Street, *c.* 1920.

In the 1970s it was surrounded by office blocks and fell out of use as a church and was used for educational purposes. At that time a very unusual fire escape was installed, which involved a section of the church's wall opening outwards on rails to provide an escape route.

Animals, The

The successful 1960s pop group The Animals featuring Eric Burdon, Chas Chandler, Alan Price, John Steel and Hilton Valentine hailed from Newcastle originally. Their most famous song 'House of the Rising Sun' in 1964 was a transatlantic hit and has been called the first folk rock hit. Unfortunately it was not named after the Wallsend Rising Sun Colliery as many locals believed at the time.

Angel of the North

Anthony Gormley's Angel of the North, which was erected in 1998 in Gateshead overlooking the A1, is a relatively new icon of the North East. It complements the Tyne Bridge as a symbol of the 'Geordie Nation'. When it was proposed and first built it divided opinion but the doubters have almost all been persuaded that it is a great artwork welcoming people to Tyneside.

Ant and Dec

Anthony McPartlin and Declan Donnelly started their acting careers on the children's television series *Byker Grove* in the early 1990s alongside Jill Halfpenny and many other budding stars. They then briefly became pop stars known as PJ and Duncan (their names on *Byker Grove*) before they were asked to present various popular television shows, starting with *SMTV Live* in 1994. They are now television legends winning countless awards for such shows as *Saturday Night Takeaway*, *I'm a Celebrity ... Get me out of Here* and *Britain's Got Talent*. They have now won the Most Popular Entertainment/TV Presenter award seventeen years in a row.

Ameobi, Shola

Shola Ameobi and his family grew up in Fenham after moving from Nigeria where he was born. He and his younger brother Sammy joined Newcastle United Academy and both eventually played for the first team but only briefly at the same time. Shola has gone down in legend as the 'Mackem Slayer' as he always seemed to score against Sunderland. He played for over fourteen years in the first team under a number of famous managers, scoring seventy-nine goals in 397 games between 2000 and 2014. He played for England under-21s for three years from 2000 and later played for Nigeria from 2012 to 2014.

Arena

The Metro Radio Arena was built in 1995 by former The Animal's member Chas Chandler and his partner Nigel Stanger. It was originally called the Newcastle Arena then the Telewest Arena until 2004. It opened as a music and sports arena and hosted

basketball and ice skating in the early years. All the top acts have appeared here including David Bowie, Elton John, Diana Ross, Beyonce, Take That, the Spice Girls, Little Mix and Pavarotti.

Armstrong, Lord William

William Armstrong was one of Newcastle's and the North East's most famous sons. His influence is still all around us today and not just because he has a statue outside the Great North Museum. He started life as a lawyer following in his father's footsteps but his real desire was to become an inventor. He invented a hydraulic crane, which he set up on the Quayside to prove it was better than other cranes, and then set up his own factory to build them. He turned his attention to guns and armaments and revolutionised the design and effectiveness of certain weapons. He is sometimes called the inventor of modern artillery. He then built a massive factory at Scotswood known as Armstrong Whitworth to supply arms to the world. He also built a new shipbuilding enterprise after the Swing Bridge, which he designed. It was opened to allow ships to be built west of Newcastle. The Armstrong Factory is featured in the famous Geordie song 'The Blaydon Races' and continued as a major employer on Tyneside for well over 100 years. He lived in a large house with Jesmond Dene as his garden before he gave it to the residents of Newcastle to use as a public park. He was generous to the College of Science at the Newcastle division of Durham University (later becoming Newcastle University), which had its principal building named after him as the Armstrong buildings and Armstrong tower. He became Lord Armstrong in 1887 in recognition of his contribution to industry and philanthropy. William and his wife moved to Cragside near Rothbury, which became the first house in the world to be powered by hydroelectricity, using incandescent light bulbs invented in Newcastle by Joseph Swan. It is now owned by the National Trust and is one of their top-five visitor attractions in England.

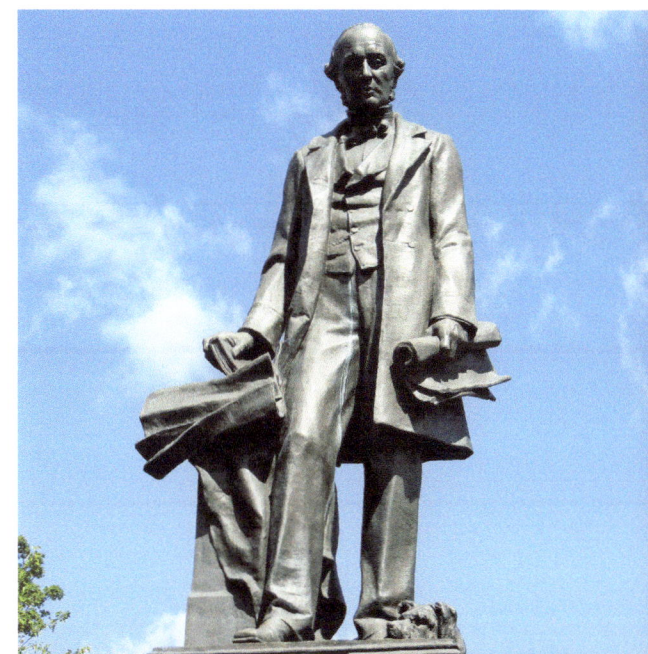

Lord Armstrong statue outside the Great North Museum.

A–Z of Newcastle

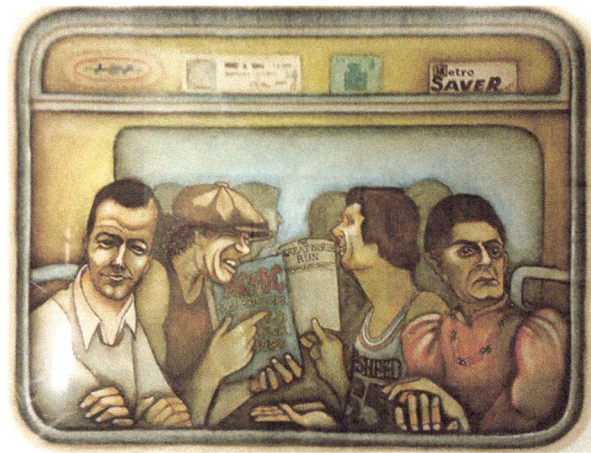

From left to right: Alan Shearer, Brian Johnson, Brendan Foster, Rowan Atkinson. Monument Metro station.

Assembly Rooms

The present Assembly Rooms were opened in 1776 and replaced earlier Assembly Rooms on the opposite side of Westgate Road where Charles Avison organised his concerts.

Atkinson, Rowan

Born in Consett and educated at Newcastle University, the now famous actor will have visited on many occasions before he gave up electrical engineering for *Blackadder* and *Mr Bean*. He is featured as Blackadder on a mural of famous Geordies in the Monument Metro station where he is seen sharing a carriage with Alan Shearer, Brendan Forster and Brian Johnson.

Auf Wiedersehen, Pet

This 1980s TV comedy launched the careers of Tim Healey, Jimmy Nail and Kevin Whately, who formed a team of unemployed bricklayers who had to seek work in Germany. It was written by Dick Clement and Ian La Frenais, and it was later brought back in 2003 when the Transporter Bridge from Middlesbrough ended up in America and in 2004 the team found themselves in Cuba.

Avison, Charles

In the eighteenth century Charles Avison was one of England's foremost composers. He was advised to move to London to take advantage of his talent and fame but he was not happy there. He came back to Newcastle to organise his own concerts at the Assembly Rooms, which were so popular that people travelled from all over the north to attend them. As a day job he travelled to the grand houses of the aristocracy such as Gibside teaching music to the gentry and he was organist at St Nicholas' and St John's churches. Unfortunately his music fell out of favour, unlike his contemporaries Wagner and Handel, and few people have now heard of him. He died in 1770 and is buried in St Andrew's churchyard close to where he was born in 1709.

B

Bainbridge's

The John Lewis store in Eldon Square will always be known by locals as Bainbridge's. The original store on Market Street was one of Newcastle's first department stores and was founded by Emerson Muschamp Bainbridge in 1838.

Balmbras

In 1862 Geordie Ridley first sung his song 'Blaydon Races' in the famous Balmbras Music Hall. It is now known as the Geordie anthem, and the building is still in the Cloth Market with plans to restore it to its former glory.

Barbour, Dame Margaret

Dame Margaret Barbour is company chairman of J. Barbour & Sons, who have a factory manufacturing outdoor clothes in South Shields. She is credited with revitalising the outdoor waxed jacket to be a popular fashion accessory among the rich and famous, leading to a massive expansion of the company. She set up the 'Women's Fund' in 1999, in Tyne and Wear and Northumberland, to encourage women to fulfil their full potential, as well as helping the disabled in the community. She was awarded a doctorate of civil law by Newcastle University.

Baltic

The Baltic Centre for Contemporary Art is another of Newcastle and Gateshead's major tourist attractions sitting close to the Gateshead Millennium Bridge and the Sage Music Centre. It was opened in 2002 in the former Baltic Flour Mill, which was built in 1950 as a centre for modern art and hosted the Turner Prize in 2011. It is free to enter and the viewing platform and gallery offer fantastic views of the river gorge and its seven bridges. (*See* page 55 for image.)

Beardsley, Peter

Local lad Peter Beardsley, from Longbenton, was twice a player at Newcastle as well as taking on a number of roles on the coaching side for the club including caretaker manager. Sadly he received most of his honours when playing for Liverpool. He will always be remembered as one of Newcastle and England's most skilful and entertaining players. He played 276 times for Newcastle scoring 108 goals and played fifty-nine times for England getting nine goals. (*See* mural on page 12.)

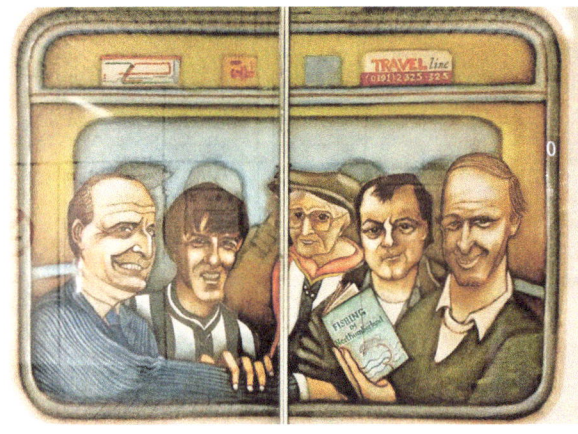

From left to right: John Hall, Peter Beardsley, Catherine Cookson, Tim Healey, Jack Charlton. Monument Metro station.

Bell, Gertrude

In 2015 the Great North Museum mounted an exhibition to celebrate the life of Gertrude Margaret Lowthian Bell (1868–1926), the granddaughter of Newcastle industrialist Isaac Lowthian Bell. She was a famous writer, archaeologist, explorer and traveller in the Middle East, sometimes called 'The Queen of the Desert', who was a friend of Lawrence of Arabia and an advisor to Winston Churchill. She was credited with helping to establish the archaeological museum in Baghdad as well as contributing to defining the land boundaries of Iraq after the First World War.

Bell, Sir Isaac Lowthian

Sir Isaac Lowthian Bell (1816–1904) was born in Newcastle and was an ironmaster and a partner in Losh, Wilson & Bell, which had a factory in Walker as well as in Middlesbrough. He was Mayor of Newcastle in 1854 and 1862 and he gave money to help to set up the present university. Part of Armstrong buildings has a Lowthian Bell tower.

Bell Scott, William

The Scottish artist William Bell Scott (1811–90) moved to Newcastle in 1843 to be principal of the Government School of Art in Newcastle. He was a close friend of Dante Gabriel Rossetti, the famous Pre-Raphaelite painter who visited him in Newcastle. He lived in St Thomas's Crescent and had a studio to the rear that has survived and is used by the local community as a meeting room. He left Newcastle in 1868, but during his time in the area he left his mark at Wallington Hall in Northumberland. Here he produced a number of wall paintings between 1855 and 1860 depicting scenes from the North East, including an emotive industrial scene depicting workers on the riverside at Newcastle, with the High Level and Georgian bridges in the background.

Bessie Surtees House

This impressive medieval merchant's house on The Close is the headquarters of English Heritage and Historic England in Newcastle. It gets its name from Bessie Surtees, the daughter of Aubrey Surtees who intended his daughter to marry

B

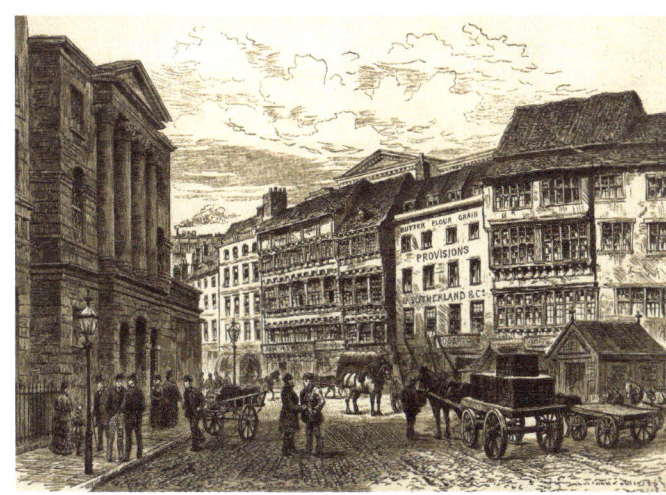

Sandhill with Bessie Surtees House and the Guildhall, c. 1887.

a rich friend of his. On 18 November 1772 Bessie climbed down a ladder from a first-floor window to elope with John Scott from Love Lane in Scotland. John Scott later became Lord Eldon (Eldon Square Shopping Centre was named after him) and Lord Chancellor of England and her father did forgive her in time.

Bewick, Thomas

Thomas Bewick (1753–1828), the famous woodcarver and natural history author, had a workshop in Amen Corner where he started work as an apprentice to Ralph Beilby and later took over the business. He lived for some time in a house in the Forth area, which is now appropriately named Bewick Street. On the pavement, below a blue plaque to Thomas Bewicke, is a large artwork showing his famous Chillingham Bull.

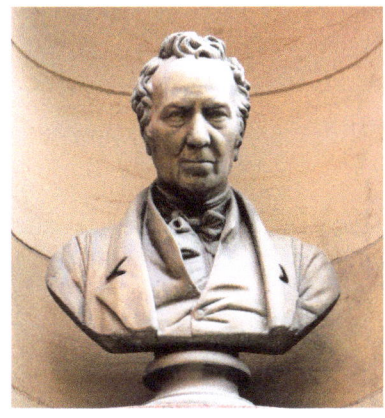

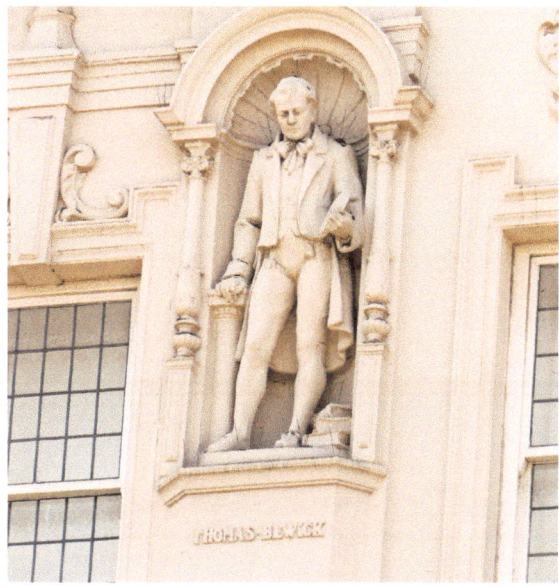

Thomas Bewick, Amen Corner and Northumberland Street.

Bigg Market

The original Bigg (a type of barley) Market was established in medieval times north of the parish church of St Nicholas. It was on the main route between the bridge over the Tyne that came up Side past the castle and through the New Gate on the way to Scotland. The wide open space was a natural meeting point in the town and has remained so. It was until recent years the centre of Newcastle's nightlife. It is ironic that the John Rutherford fountain, a monument to one of Newcastle's leading temperance advocates, is situated in a prominent location stating that 'Water is Best'.

Blackett Street

The Blackett family were one of the wealthiest Newcastle families and at one time lived in Newe House or Anderson Place, the large mansion within the town walls that was later developed by Richard Grainger to form Grainger Town. Blackett Street was named after John Erasmus Blackett (1728–1814), who was mayor four times during the eighteenth century, and his daughter Sarah married Admiral Cuthbert Collingwood in 1805.

Blackfriars

Dominican monks founded the Blackfriars monastery in Newcastle in 1239 and occupied the site until Henry VIII dissolved the monasteries in 1539. The church was demolished but the buildings were spared and used by the Newcastle Guilds for hundreds of years. The Smiths Company still occupy part of the buildings. Later they were used as overcrowded dwellings before becoming derelict and were nearly demolished in the 1960s. Luckily Newcastle Council encouraged their restoration

Blackett Street and Eldon Square looking east in 1904.

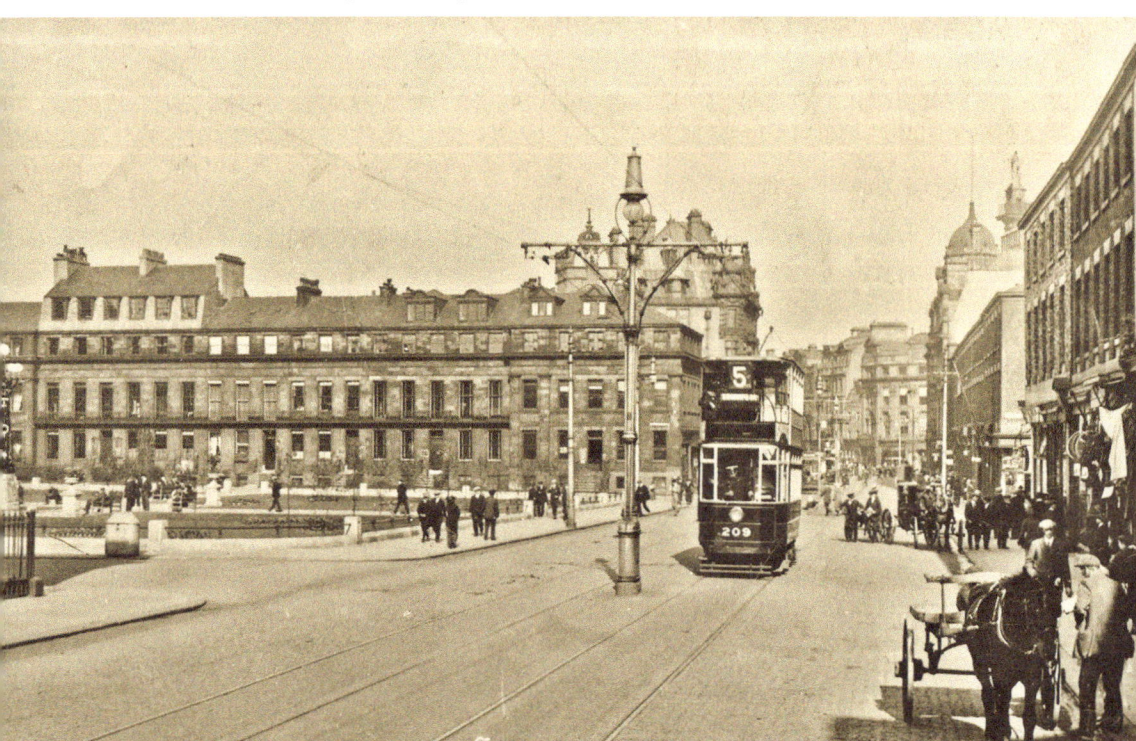

B

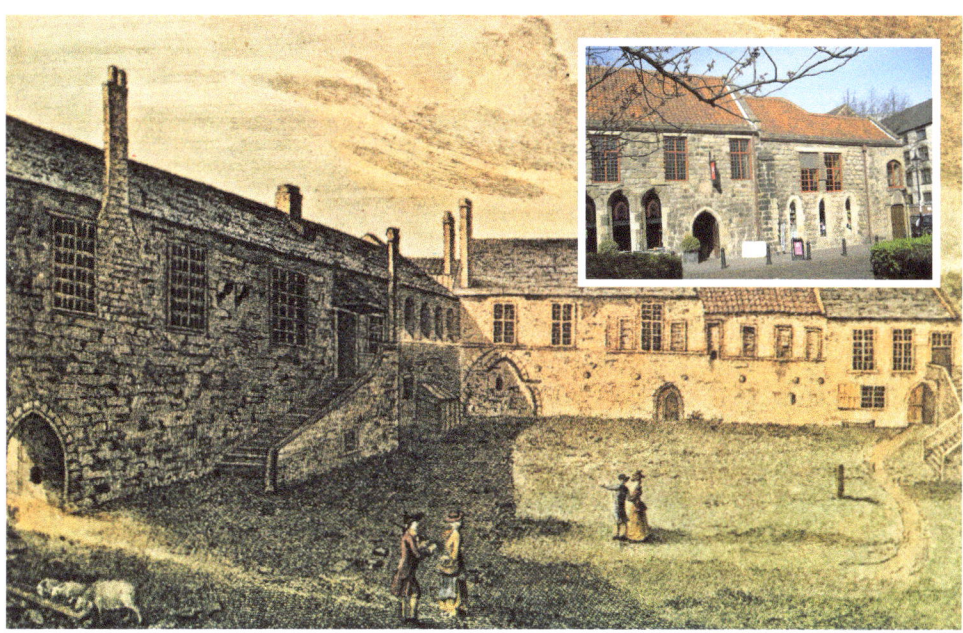

Blackfriars, Friary Lane.

and the Queen Mother opened them in 1981. Presently they are mainly used as a restaurant, shops and offices.

Black Gate

Originally built as an extra defensive gate to the north of the castle in 1247, the present Black Gate is a much taller building as upper floors were added in the seventeenth century when it was converted into living accommodation. It got its name from Patrick Black who lived here, not because of the smoke-blackened walls. It now forms part of a joint tourist attraction with the castle keep and is open most days for visitors to discover its many secrets.

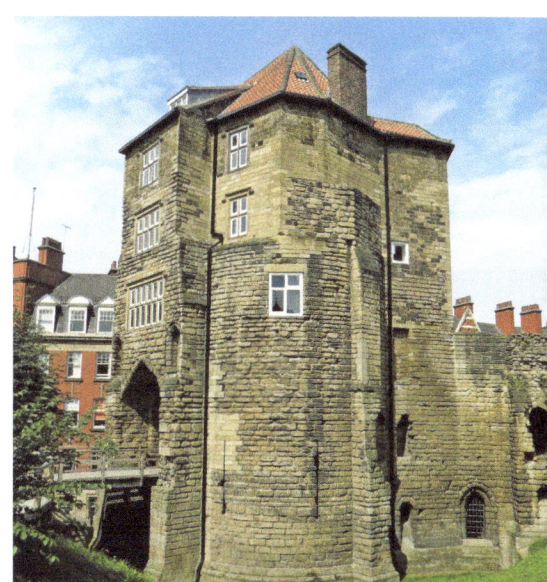

Black Gate, Castle Garth.

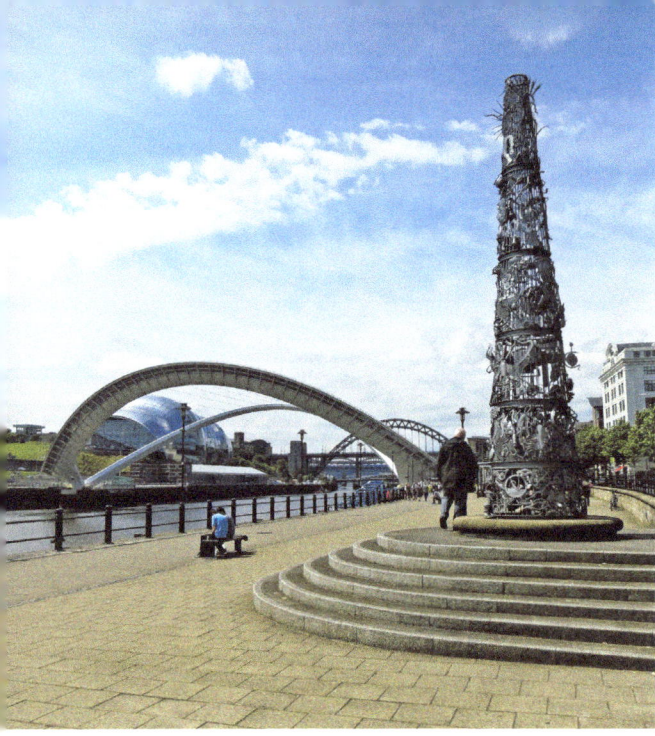

Quayside, *Blacksmith's Needle* and the tilting Millennium Bridge.

Blacksmith's Needle

Forming one of a number of impressive artworks on the East Quayside, *Blacksmith's Needle* was erected in 1997 and appeals to all generations. It was constructed by apprentice blacksmiths and has six parts that use objects referring to the five senses and the fabled sixth sense. It is a challenge to all to identify which sense is represented at each level and you can ring the bell to celebrate.

Bolam, James

The famous North East TV actor James Bolam made his name as Terry in the *Likely Lads*. He then went on to star as Jack Ford in *When the Boat Comes In*. He had a very busy acting career in a wide range of roles including more recently as one of the ageing cops in *New Tricks*.

Buddle, John

He was known as the 'King of Coal' and John Buddle's funeral cortege in 1843 was over 1 mile long, as it snaked from Wallsend to St John's Cemetery in Elswick, where he was buried close to a coal seam. He took over from his father as manager at Wallsend Colliery in 1806 and soon built up a reputation as the first modern mining engineer. He introduced many new improvements to working conditions in mines, especially improving ventilation, and Sir Humphrey Davy developed his safety lamp at Wallsend in 1815. Despite this invention numerous disasters still occurred, including the worst ever to date at Wallsend in 1835 when 102 men and boys were killed. He gave evidence to the subsequent inquiry into the accident as well as at many other disaster inquiries and he continued to look for ways of improving safety.

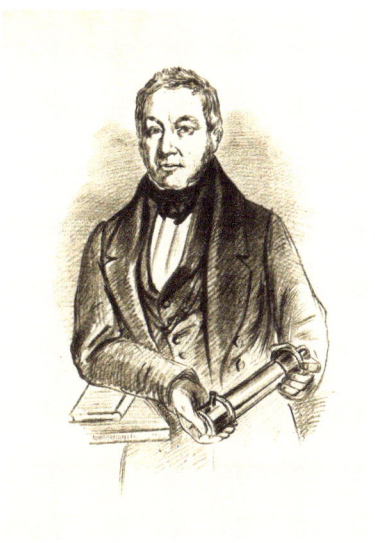

John Buddle.

Burn, Sir John

Sir John Burn went to Newcastle University, later becoming an expert in genetics and cancer and being appointed professor of Clinical Genetics at the university in 1991. He helped to set up the Centre for Life in Newcastle. It is part of the university and is an education and science centre, situated close to Central station. He was knighted in 2010 for services to medicine.

Burt, Thomas

The first former miner to become an MP was Thomas Burt (1837–1922.) He was MP for Morpeth from 1874 to 1918 and in later life became the Father of the House of Commons. He was born in Backworth and became a miner before rising through the ranks to become secretary of the Northumberland Miners Association in 1863. Burt Hall was built in 1885 in Northumberland Road and named in his honour.

Byker Grove

The children's television show *Byker Grove* (1989–2006), which launched the careers of Ant and Dec, Charlie Hardwick and Jill Halfpenny, ironically was not filmed in Byker but in the west of the city at Benwell Towers.

Byker Wall

The iconic landmark Byker Wall is one of a few public housing estates in Britain to become a listed building. It was built in the 1970s following slum clearances and was designed as a barrier to a proposed motorway. It was designed by Ralph Erskine and the community-led design has led to it gaining many architectural awards.

C

Carmichael, James Wilson

James or John Wilson Carmichael (1800–68) was a talented marine and landscape artist who was born at the Ouseburn to ship carpenter William Carmichael. He spent three years at sea as a young man and then took up drawing work and developed his skill as a painter. He was soon being commissioned to paint for Trinity House and the Newcastle Corporation. He later worked closely with John Dobson in producing drawings of his proposed buildings such as the St Thomas's Church, the Guildhall and Central station. He also painted the proposed High Level Bridge for Robert Stephenson. Many of his works can be seen at the Laing Art Gallery and Trinity House.

Castle

Newcastle Castle is usually thought of as the large keep building that forms the prominent landmark overlooking the river. The castle itself was a much larger series of structures contained within a curtain wall, some of which still survives overlooking the river between the Moot Hall and the Bridge Hotel. The Black Gate itself formed a defensive bastion gate protecting the walls of the castle. The present stone keep forms part of the second castle on the site, built by Henry II in 1178 on top of the original Roman fort that occupied the site. The original Norman castle took the form of a motte-and-baily castle erected by William the Conqueror's son Robert Curthose

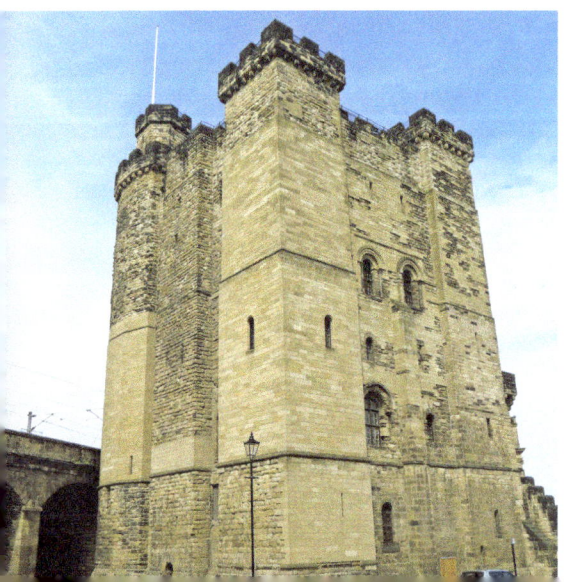

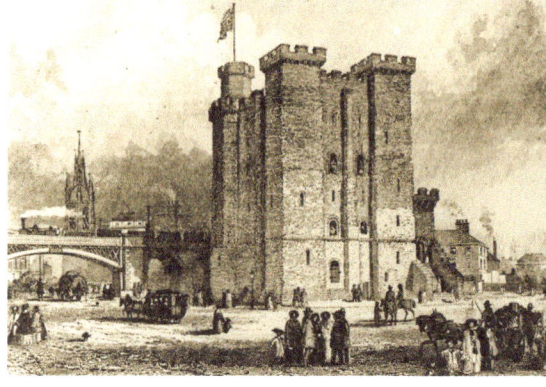

Castle Keep, Castle Garth.

C

in 1080. In 1812 the former flat-topped unroofed ruin of a keep was beautified by Newcastle Corporation to make it look like a 'proper' castle with battlements.

Central Arcade

This unusual impressive triangular-shaped building between Grey Street, Market Street and Grainger Street was built as the Central Exchange Buildings by Richard Grainger in 1837 and now houses the ornate tiled Central Arcade. It is home to Windows Music, shops, flats and offices. The arcade dates from 1906 when it was rebuilt following a fire. The building had previously been used as a private club, reading rooms, art gallery, a concert hall and a hotel.

Central Station

John Dobson designed a very special railway station to celebrate the railway heritage of the town and region. The unique design of the curved steel and glass roof is still as impressive now as it was when the station opened and has since been copied many times throughout the world. Queen Victoria officially opened the station in 1850 and it was a further twelve years before the portico was built by Thomas Prosser to a Dobson design.

Chambers, Robert

Trained by the famous rower Harry Clasper, Robert Chambers (1832–68) also became a world champion rower. He won the World Sculling Championship in 1859 and together with James Renforth was one of the three nineteenth-century Tyneside rowing sports superstars. He was born in Walker and lived in Newcastle and, like his other two fellow rowers, became a pub landlord later in life.

Central station, Neville Street.

Charlton, Jack

The 1966 World Cup winning footballer Jack Charlton, along with his brother Bobby, were born in Ashington and were related to Newcastle United's famous centre forward Jackie Milburn. Jack played over 600 games for Leeds and later went on to manage Newcastle United from 1984 to 1985 and then had a very successful spell as manager of Ireland from 1986 to 1996. (*See* page 12 for mural.)

Chaplin, Sid

Sid Chaplin (1916–86), a well-known local writer and playwright, started life working in the coal mines and used his writing skills to become a writer for the National Coal Board before leaving to become a freelance writer. He wrote mainly about life in the North East and coal mining in particular. He helped to write the TV series *When the Boat Comes In* and the play *Close the Coalhouse Door*. His books included *The Thin Seam, In Blackberry Times* and *The Day of the Sardine*. His papers are held at Newcastle University and he is buried in Jesmond Cemetery.

City Hall

This complex of buildings including the City Hall and Baths were built in 1928. The City Hall was Newcastle's premier music venue for many years and all the top acts including The Beatles and The Doors appeared here until the Arena was built. Every December, during the 1970s to the 1980s, local group Lindisfarne put on their legendary Christmas concerts to sell out audiences singing 'Fog on the Tyne'.

China Town and Chinese Arch

China Town developed in Newcastle around the Stowell Street area from the 1970s. In 2005 the Chinese Arch was built to form an entrance way from Gallowgate. The impressive arch was made in China and constructed on site by specialist Chinese workmen. It incorporates many local landmarks including Grey's Monument and the Tyne Bridge in the intricate design.

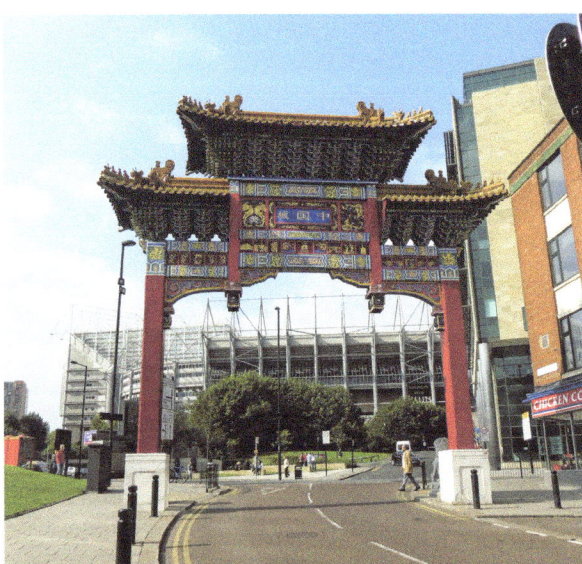

Chinese Arch, Gallowgate.

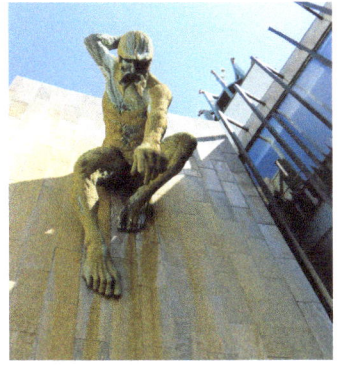
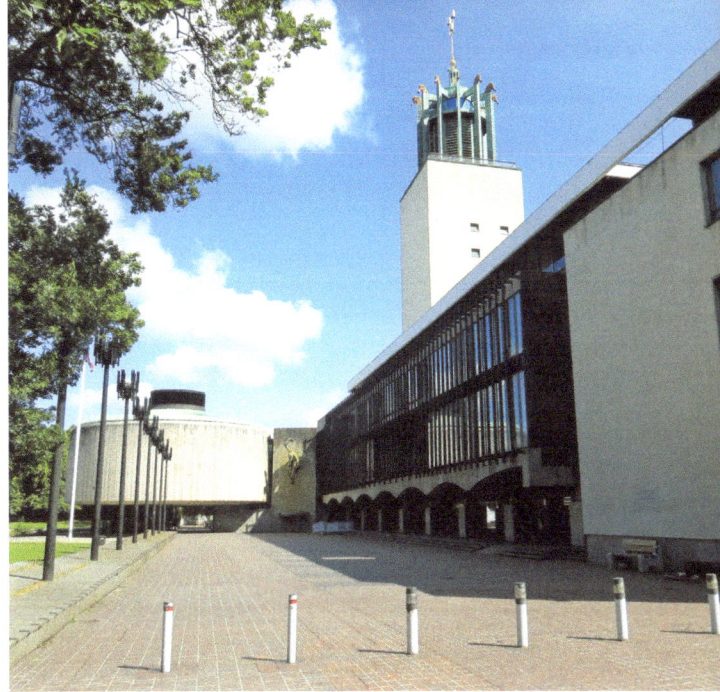

Civic Centre and Tyne God, Barras Bridge.

Civic Centre

The iconic Civic Centre is a Grade II*-listed building and built between 1958 and 1968. It was designed by the city architect G. W. Kenyon and quality materials were used throughout. The white Portland stone tower is surmounted with a carillon bell tower surrounded by twelve gigantic seahorse heads and above them three golden castles reach out to the sky. More artwork can be found in, on and around the building, which has served as the council headquarters since departing from the old 1860s Town Hall in the Big Market.

Clark, George

'Restoration Man' TV architect George Clark from Washington went to university in Newcastle before making a name for himself with his 'Amazing Spaces' on television. He has recently helped to design some of the housing being built on the former Smith's Dock in North Shields.

Clasper, Harry

One of three famous Tyneside rowing superstars Harry Clasper (1812–70) was the first to become world champion in 1845. He rowed with his brothers in a boat he had helped to design and build. He is still credited with various inventions including the use of outriggers, which transformed the sport. Geordie Ridley penned the 'Blaydon Races' in honour of Harry Clasper, who had just retired, and it was first performed in 1862 at Balmbra's Music Hall. The play *Hadaway Harry*, which was performed at the Theatre Royal and other venues, was written by Ed Waugh to record his rowing feats.

Clayton Street.

Clayton, John

John Clayton was town clerk of Newcastle from 1822 to 1867 and followed his father in the role. Clayton Street was named after him as he worked very closely with Richard Grainger in redeveloping the centre of Newcastle in the 1830s and 1840s in the Tyneside classical style, and the area is now known as Grainger Town. He was also a famous antiquarian and lived at Chesters on Hadrian's Wall. He bought up large stretches of the wall and a number of Roman forts including Chesters and Housesteads. He then excavated many sites and exposed large sections of Hadrian's Wall preserving them for future generations.

Collingwood, Admiral Lord Cuthbert

Cuthbert Collingwood was born in Newcastle in 1748 not far from St Nicholas' Church, where he later married Sarah Blackett in 1791 and where there is now an impressive memorial to his life and achievements. The street to the west is called Collingwood Street, built in 1810, the year of his death, and it terminates at Westgate Road close to where he went to school at the Royal Grammar School. He spent most of his working life at sea, starting aged twelve and rising through the ranks. He was a close friend of Horatio Nelson and they fought together many times in major naval battles. Collingwood famously was the first to engage the enemy in the Battle of Trafalgar in 1805 and when Admiral Nelson was killed Collingwood assumed command and went on to win the battle. His reward was to be appointed vice admiral and he was also made a lord. He was not allowed to return home as his experience was needed when he was appointed Commander in Chief of the Mediterranean Fleet. Five years later he died on his return home after becoming gravely ill.

Collinwood Bruce, John

Reverend John Collingwood Bruce is regarded as one of the first great authorities on Hadrian's Wall. In 1863 he wrote his *Handbook to the Roman Wall*, which has been updated and reprinted many times since. Every ten years there is a 'Pilgrimage' along Hadrian's Wall where over 200 enthusiasts follow in the footsteps of his first journey in 1849. He graduated in Glasgow then became a Presbyterian minister and schoolmaster and he later took over as head at Bruce's Academy, a school founded by his father (and attended by Robert Stephenson). His main interest was in Roman remains and he became an active member of the Society of Antiquaries in Newcastle, specialising on Hadrian's Wall in particular. There is an impressive memorial to him in St Nicholas' Cathedral.

Cook, Jason

Before co-writing and starring in the television series *Hebburn*, Jason Cook started his career as a stand-up comedian in Newcastle. He was born in Hebburn in 1973 and went to college in South Shields.

Cookson, Dame Catherine

The famous writer from South Shields, known in her autobiography as 'Our Kate' and who was for years the most read author in British libraries, has left a lasting legacy on Tyneside through her charities. She set up the Catherine Cookson Foundation in the 1980s, which provides money for research at Newcastle University as well as setting up the Catherine Cookson Trust in 1977, which still gives grants to a wide range of charitable organisations. She has given over £1 million for research in connection with haematology and millions of pounds through the trust. She wrote over 100 books that sold over 100 million copies worldwide. Many were based on Tyneside and a large number have been made into films. She died in 1989 aged ninety-one in Newcastle and her husband Tom, who she had been married to for fifty-eight years, died only seventeen days later. She can still be seen every day in Monument Metro station as the only woman featured on a mural to local heroes. (*See* page 12 for mural.)

Corvan, Ned

Edward 'Ned' Corvan (1830–65) was a performer, songwriter and the proprietor of a popular music hall in South Shields in the mid-nineteenth century. He started life in poverty in Newcastle and joined Billy Purvis in his Victorian Theatre to learn his trade. He could play the violin but was best known for his comedy as he sang songs in the local Geordie dialect, many of which were later printed in a series of Corvan's song books.

Cowen, Joseph, MP

Joseph Cowen was often referred to as the 'Blaydon Brick' as his family ran brickworks in Blaydon. He was the owner of the *Newcastle Daily Chronicle* and built the Tyne Opera House and Theatre (at one time the Stoll Picture House) as a working man's alternative

Joseph Cowen statue, Westgate Road.

to the Theatre Royal. He was Liberal MP for Newcastle from 1874 to 1886, taking over from his father Sir Joseph Cowen. He was well known for his radical views and over the years he invited a number of radical thinkers to Newcastle including Giuseppe Garibaldi, the Italian freedom fighter. A statue to him was erected in Westgate Road in 1906.

Cram, Steve

Steve Cram, or the 'Jarrow Arrow', was awarded an honorary degree by the Northumbria University in 2003. He was an international athlete winning World Championships, an Olympic silver medal in 1984 in the 1,500 metres and numerous middle distance world records before becoming a well-known athletics commentator.

Crocodile Shoes

Filmed in and around Newcastle and starring Jimmy Nail with support from Sammy Johnson, *Crocodile Shoes* was on TV from 1994 to 1996. The main character Jed Shepperd was a factory worker who wrote country and western songs and wore crocodile shoes. He was looking to break into the music industry and fittingly the song and album called *Crocodile Shoes* were great hits for Jimmy Nail as he did have his own break into the world of music.

Crown Posada

One of the oldest pubs in Newcastle, the Crown Posada is situated on Dean Street and is said to be over 230 years old. It has lots of character to go with its unusual name, which is said to be linked to a former seafaring owner who had a wife in Spain and a mistress in Newcastle. It is believed he added 'Posada', which is Spanish for an inn, to the original name of the pub called The Crown. In 2015 a mural showing Spanish dancers was discovered on a wall under wall coverings during a renovation.

Cycle Hub and C2C

The Cycling Hub houses a café, bike hire and workshop facilities aimed at cyclists using the riverside cycle routes. It is situated on the riverside to the east of the Ouseburn and is on the route of the C2C (Coast to Coast) national cycle route. Newcastle and Tyneside generally has an extensive network of on- and off-road cycle routes.

D

Darling, Julia

Julia Darling was a well-known local poet, fiction writer and playwright who wrote novels and numerous books of poems. She strongly believed that poetry could have a positive effect on health and after being diagnosed with breast cancer in 1994 she wrote many poems based on her own experience. She died aged forty-eight in 2005 and is buried in Jesmond Cemetery. One of her poems called 'Old Jezzy' refers to the plot she had picked for herself as her final resting place.

Dean Street

Dean Street was built around 1790 over the open sewer of the Lort Burn, which flowed under the Low Bridge, which had to be demolished as part of the road construction. It linked Sandhill with the upper town and the new Moseley Street linked it to Pilgrim Street to the east and St Nicholas' Church to the west.

Diamonds Speedway

Newcastle Diamonds motorcycle speedway team was established in 1928 at the Brough Park track, now called Newcastle Stadium, in Walker. The team has had mixed success over the years with world champions such as Ivan Major riding for them in the 1960s. They compete in the Speedway Great Britain (SGB) Championship below the Premier League, a league they last won in 2001.

Discovery Museum

The former Co-op head office and warehouse is now one of Newcastle's outstanding museums and the home of the famous *Turbinia*, the first turbine-powered vessel in the world, invented by Charles Parsons. In 2018 as part of the Great Exhibition of the North it will also have the famous locomotive *Rocket* on display in its hometown for the first time since 1862 after it was built in Newcastle (in 1829) by George and Robert Stephenson. The Discovery Museum celebrates Tyneside's important industrial history in all forms including shipbuilding, engineering, coal mining, electricity generation and lighting to name but a few of the elements in the city's contribution to the Industrial Revolution. Tyne & Wear Archive service is also based here housing millions of records.

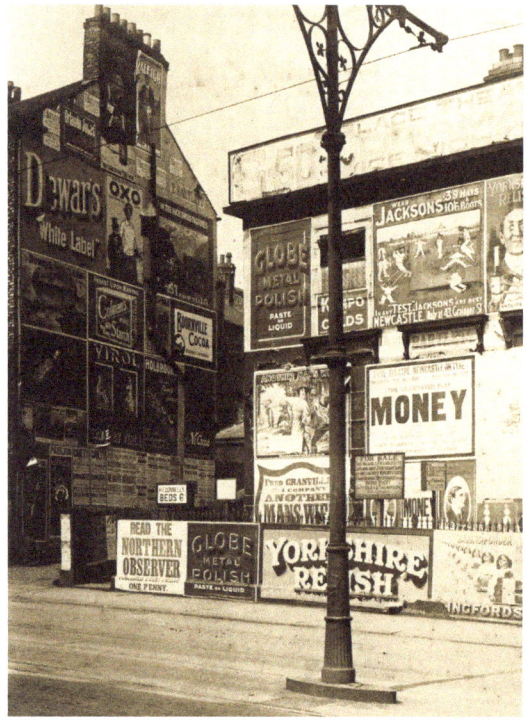

John Dobson's House, New Bridge Street, in 1911 behind adverts.

Dobson, John

John Dobson is usually referred to as Newcastle's best architect. He lived on New Bridge Street in the house he built for himself in 1823. He was a prolific architect designing all types of buildings in a wide range of styles throughout Newcastle and also around the region. His work includes Central station, the east side of Grey Street, Eldon Square, Grainger Market and St Thomas's Church in Newcastle. Elsewhere he built numerous country houses such as Mitford Hall and structures as varied as the base for Collingwood's Monument in Tynemouth, the north breakwater at Cullercoats and Morpeth Gaol.

Dog Leap Stairs

One of the most unusual street names in Newcastle is a set of stairs rising from Side close to Dean Street bridge and leading steeply to Castle Garth beside the Black Gate. However, it does not mean that a dog jumped down the hill at this point as it suggests but is a corruption of the earlier name of Dog Loup, meaning narrow gap between buildings.

Douglas Frederick

The famous African-American abolitionist, author, social reformer and former slave visited Newcastle in 1846, the year he formally bought his freedom. He stopped at No. 5 Summerhill Grove with the Richardson family who were anti-slavery activists and helped to raise the funds to buy his freedom.

E

Eagles

Newcastle Eagles are one of the top basketball teams in Britain. They were established in 1976 in Washington but became the Newcastle Eagles in 1996. They were originally based in the Metro Arena and are now in the Northumbria University Sport Central. They have dominated British basketball for years winning countless trophies under the direction of head coach Fabulous Flournoy.

Edwards, Jonathan

The most famous Olympic gold medal triple jumper Jonathan Edwards has many links with the North East including studying at Durham University, appearing many times at the Gateshead International Stadium and now lives in Newcastle. Despite at one time refusing to compete on a Sunday for religious reasons he still managed to win gold medals in the World Championships, European Championships and the Commonwealth Games as well as breaking many world records. He later became a sports commentator.

Eldon Square and Lord Eldon

John Scott (1751–1838), who famously eloped with Bessie Surtees in 1772, later became Lord Chancellor of England and was made Lord Eldon in 1801. When Richard Grainger and John Dobson built a prestigious square of grand houses in 1826, they named it Eldon Square after him.

Eldon Square Shopping Centre

Eldon Square shopping area was built in the 1970s and controversially demolished two sides of the square, with only the eastern side surviving. The state-of-the-art modern indoor shopping complex formed part of Newcastle's ambitious plans to consolidate Newcastle as the region's capital. It has since been upgraded a number of times and still remains a firm favourite with the thousands of shoppers who flock there every day.

Emerson Chambers

Built in 1904, Emerson Chambers represents some of the finest Edwardian period architecture in Newcastle. It was designed by Benjamin Simpson of Simpson, Lawson & Rayne with his trademark green copper dome. It was built for local brewer Robert Emerson. It has had many uses over the years and the basement floor was the site of the first Chinese restaurant in Newcastle in the 1950s.

Above: Eldon Square Shopping Centre, 1976, and Eldon Square in the 1820s.

Below: Exhibition Park in 1887 and 1929.

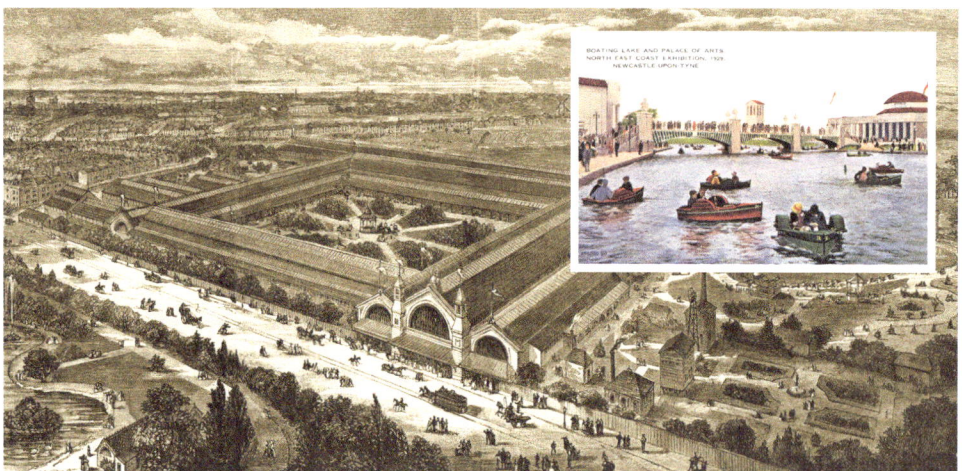

Exhibition Park

This part of the town moor formerly known as the Bull Park was where the council kept the town bull. It was the site of the Jubilee Exhibition to celebrate Queen Victoria's fifty years on the throne in 1887. Exhibition Park was later used in 1929 for the North East Coast Exhibition and in the 1970s for the Tyneside Summer Exhibitions.

F

Falcons

Newcastle Falcons Rugby Club play in the Premier League and are based at the Kingston Park Stadium. They were formed in 1996 when they took over the former Gosforth Rugby Club that had been established since 1877. The club went on to win the Premier League title in 1997/8. Their most famous home-grown player was Jonny Wilkinson, who won the World Cup in 2003 and was then voted BBC Sports Personality of the Year.

Fenwick

Fenwick department store on Northumberland Street is famous for its Christmas window display that attracts thousands of children each year. It was founded in 1882 by John James Fenwick when he converted two former houses to form his first shop, which over the years developed into the present department store.

Fire, 1854

The Great Fire of Gateshead and Newcastle started on the night of 6 October 1854 in a warehouse on the Gateshead riverside just below St Mary's Church. The warehouse blew up in a major explosion and burning debris crossed the river and set fire to the medieval buildings on the Quayside. Vast crowds were attracted to see the fire and fifty-four people were killed and over 200 houses destroyed. Gateshead's riverside warehouses were devastated and St Mary's Church was badly damaged. On the Newcastle side all the buildings fronting the Quayside between the Customs House and the Guildhall were lost and the whole area had to be rebuilt. John Dobson lost his son, Alexander, in the fire and he later designed the layout of the new streets built in Newcastle.

Fish Market

The impressive building on the Quayside between the High Level Bridge and the Swing Bridge still has a sign over the entrance to say it was the Fish Market as well as statues of Neptune and two fishwives. It was built in 1880 to replace an earlier open-air fish market on the east side of the Guildhall. It was not used for long before being converted to other uses around 1900. In recent years it has been used as a nightclub.

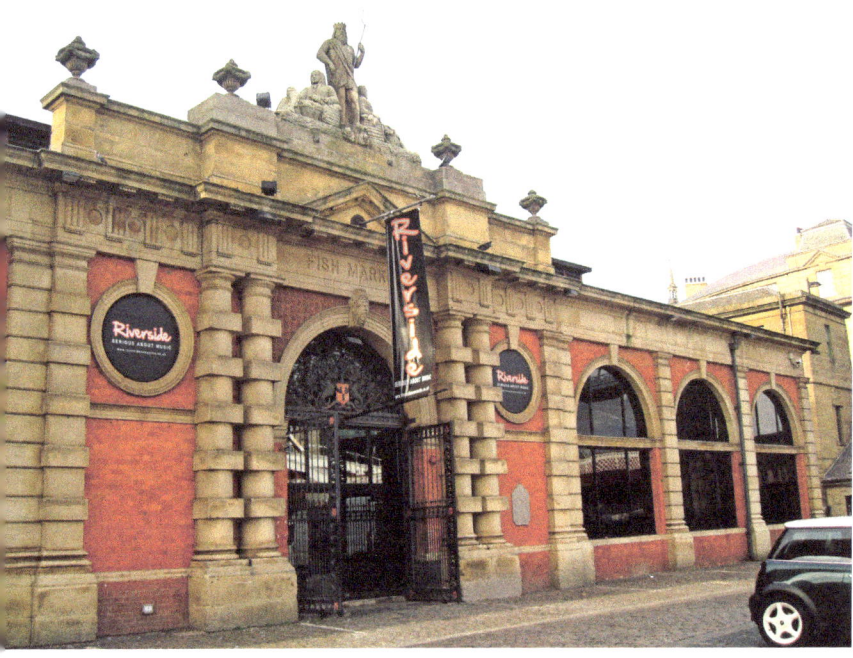

The Fish Market.

Flood, 1771

The Great Flood of 17 November 1771 followed weeks of heavy rainfall and the River Tyne was so engorged that it damaged every bridge between Hexham and Newcastle with the exception of Corbridge. At around 3 a.m. part of the old medieval bridge between Newcastle and Gateshead collapsed into the river along with many of the houses that had been built on top of it. By daylight two large sections had been swept away and these was the loss of six lives. The bridge had to be demolished and a new bridge known as the Georgian bridge was opened in 1781.

Foster, Brendan

Brendan Foster, the Olympic bronze medallist in the 10,000 metres in the Montreal Olympics in 1976, established the Great North Run in 1981. He was also a BBC commentator on athletics from 1983 until 2017. He ran for Gateshead Harriers and is known locally as the 'pied piper' of running as literally over a million people have followed in his footsteps over the Tyne Bridge in the world's biggest and best-known half-marathon (me included). He was give the Freedom of the City of Newcastle in 2016, Newcastle's highest honour. (*See* page 10 for mural.)

Freeman Hospital

The Freeman Hospital has led the way in heart and organ transplants through the pioneering work of its doctors over the years. It still continues with this work as well as being one of Newcastle's main hospitals.

G

Gallowgate

Gate was an old word for street and this street, now called Gallowgate, led to the gallows on the hill just outside the town walls close to where St James' Park is now. From as early as 1357 it was the site where executions by hanging were held, mainly prisoners held in the nearby Newgate prison, operated by Newcastle justices. In 1650 fourteen witches, one wizard and nine moss troopers were hung here on 21 August. On 14 March 1829 Jane Jamison was hanged for killing her mother in the Keelman's Hospital using a red-hot poker. The last hanging took place in 1844 when Mark Sherwood from Blandford Street rode to the gallows in a cart sitting on his coffin and came back in it. Today the south stand of St James' Park is known as the Gallowgate Stand and football has taken over from hangings to attract a mass crowd.

Garibaldi, Giuseppe

The Italian national hero and freedom fighter visited Newcastle in 1854 at the invitation of Joseph Cowen. There is a plaque on the wall of a former bookshop he visited on the corner of Nelson Street and Grainger Street to record the visit.

Gascoigne, Paul

Paul Gascoigne, or Gazza, was born in Dunston, Gateshead, and started his football career with Newcastle United as part of a successful junior team. He then made his debut for the full team in 1985. He was sold to Tottenham Hotspur in 1988 where he won the FA Cup. His most famous match was playing for England in the 1990 World Cup semi-final when he came off in tears and became a national hero. Bobby Robson described him as 'daft as a brush' and his antics off the pitch were as famous as his exploits on the pitch. (*See* page 54 for mural.)

Gate

The Gate on Newgate Street is a popular entertainment complex incorporating a multiscreen cinema, food establishments, pubs and clubs. It was built in 2002 on the site of the famous former nightclub the Mayfair.

Geordie Shore

The controversial reality show *Geordie Shore* commenced filming in Newcastle in 2011 and has proved very popular with its regular viewers, which numbered over 1 million between 2012 and 2015. It has filmed over fifteen series to date. Two of the former cast members, Vicky Pattison and Charlotte Crosby, went on to achieve fame in other reality TV shows.

George Gently

The popular TV series *George Gently* starring Martin Shaw and Lee Ingleby was filmed in and around Newcastle many times during its ten years on television from 2007 to 2017. The author once bumped into the cast in High Bridge while leading a group of visitors on a guided tour of the city and almost lost his audience as they watched Martin Shaw rehearse for the next scene.

Georgian Bridge

Following the Great Flood of 1771, when the medieval bridge was severely damaged it took ten years to build the new Georgian bridge. It was a very elegant structure with nine arches and was designed by J. Mylne. It was sometimes called Mylne's Bridge but as it was built in the Georgian era that name has been preferred. Unfortunately the Industrial Revolution led to its demise as it was an obstacle to shipping wanting to use the higher reaches of the river. It was demolished in 1867 after a temporary bridge was put in place in 1866, to the west of the bridge, during the construction of the new Swing Bridge.

Get Carter

The 1971 cult film *Get Carter* starring Michael Caine was filmed in and around Newcastle. The infamous concrete multistorey car park that dominated Gateshead town centre for decades was known as the 'Get Carter Car Park' where an unfortunate villain fell to his death at the hands of Carter. Newcastle's legendary Long Bar also featured as well as the Wallsend Ferry Landing where a Wild West-style gun battle took place. Local actor Alun Armstrong made his screen debut in the film before a long career in film and TV.

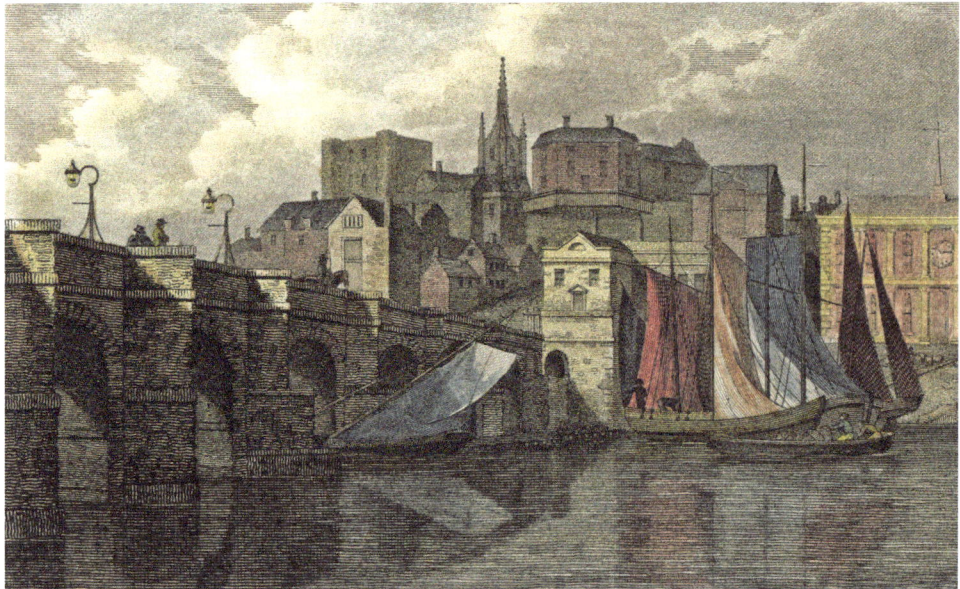

Georgian bridge on site of the Swing Bridge.

G

Grainger Market, Grainger Street.

Goal

This 1996 cult football movie *Goal* starring Kuno Becker was based at St James' Park in Newcastle and boasted thousands of Geordie extras as well as cameo roles for the Newcastle United team at the time, which included Alan Shearer. Brian Johnson of AC/DC also made an appearance.

Gosforth Park

Situated 5 miles north of the city centre, Gosforth Park is the home of Newcastle Racecourse and the Gosforth Park Hotel.

Grainger Market

Built in 1835 by Richard Grainger and designed by John Dobson, the Grainger Market replaced an earlier Flesh Market that stood in the way of the future Grey Street.

Grainger, Richard

The builder and developer of Grainger Town in the centre of Newcastle was born into a poor family and attended a charity school. He became a builder along with his brother and started building houses. Richard, with the help of generous benefactors and using John Dobson as his architect, was asked to build the grand square of large town houses at Eldon Square. Following this and with the support of John Clayton, the town clerk, he and John Dobson built the impressive indoor Royal Arcade shopping centre on Pilgrim Street – said to be the best arcade outside London at the time. In the late 1830s the large mansion Anderson Place and its vast grounds became available and was bought by Grainger with the help of John Clayton, John Dobson and others. The area now known as Grainger Town was developed over the next decade or so. The

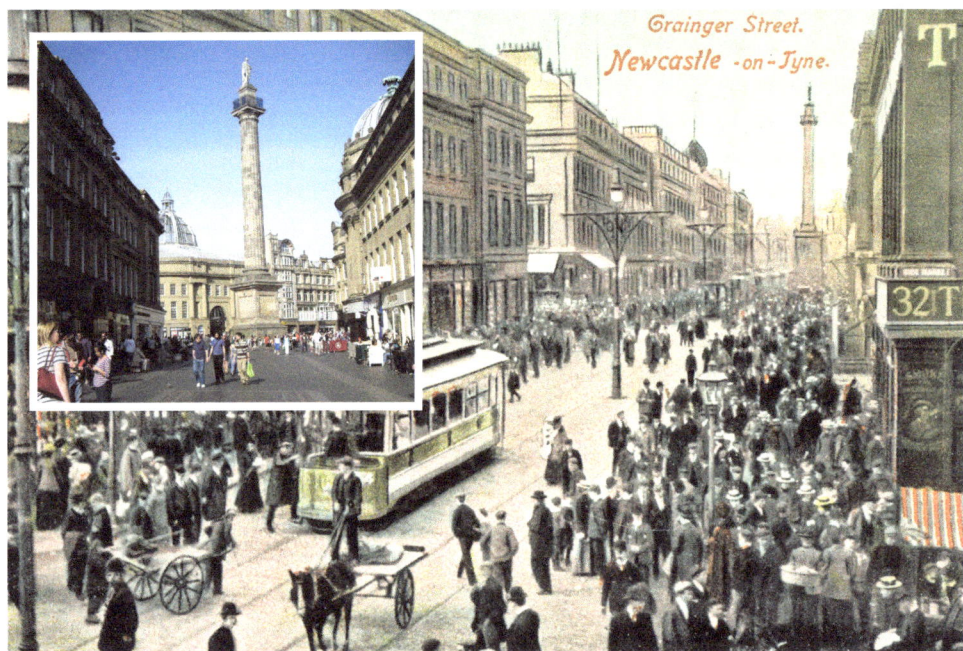

Grainger Street and Grainger Memorial.

Theatre Royal, Grainger Market, Grey Street, Grainger Street and Clayton Street were all developed in what is known as Tyneside classical style giving Newcastle centre a distinct character. Grainger lived and had his offices on Clayton Street opposite St Mary's Cathedral. He later bought Elswick Hall, but overstretched his finances and later sold it to William Armstrong. Grainger never recovered financially and unfortunately he died in debt in 1861 aged sixty-four, but John Clayton later put his affairs in order.

Great Exhibition of the North

From 18 June to 9 September 2018 Newcastle and Gateshead will host the Great Exhibition of the North to showcase the importance of the northern region in both the past and present. The three main themes of the exhibition are art, innovation and design. Many activities based around three main walking tours of the city will be organised over the summer including the return of the famous Newcastle-built *Rocket* for the first time since 1862.

Great North Museum: Hancock

The former Hancock Museum (built in 1884) was restored and extended in 2009, to form the Great North Museum: Hancock, incorporating the former Museum of Antiquaries. This free to enter museum is now a very popular tourist attraction and education resource for local school children studying natural history, Roman and Egyptian history. It was identified as one of the main hubs for the Great North Exhibition during 2018.

G

Great North Run

The world's biggest half-marathon was launched in 1981, has grown every year since and has had over 1 million runners complete the run from Newcastle to South Shields. For the three years from 2015 to 2017 the runners all followed behind the famous Sir Mo Farah.

Great Siege, 1644

Newcastle was a Royalist town during the Civil War and in 1644 the town, defended by Mayor John Marley, was besieged by Scottish soldiers under Lord Leven working with Parliamentary troops. The siege lasted for two months from August to October before the town walls were breached by explosives, and the town was then occupied by the Scots for over two years.

Green, Robson

The actor Robson Golightly Green started his acting career at the Live Theatre working with Max Adams. He was born in Hexham in 1964 and grew up in the mining village of Dudley on the edge of Newcastle as the son of a miner. He worked for two years as a draughtsman at Swan Hunters shipyard in Wallsend and starred in a local play called the *Long Line* at the Buddle Arts Centre in Wallsend, with Tim Healey watching. His film career started with Amber Films based in Newcastle and this led to his TV career and success in *Casualty* and *Soldier Soldier*. With his partner Jerome Flynn, he recorded 'Unchained Melody' in 1995, which hit the top of the record charts. They achieved a lot as singers, recording three No. 1 hit records. This success led to him being given the starring role Dr Tony Hill in his own television series *Wire in the Blood* (2002–08), which was filmed in the region. His love of fishing led to his *Extreme Fishing* programmes and his passion for the region led to the recent *Tales from Northumberland with Robson Green* series.

Grey's Monument, Charles Grey

Earl Grey tea can be bought all over the world but few people know that the man on top of the Grey's Monument is not just famous for the tea named after him. The 2nd Earl Grey, Charles Grey (1764–1845), lived at Howick Hall in Northumberland and was Whig MP

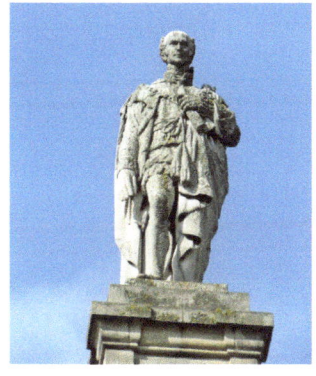
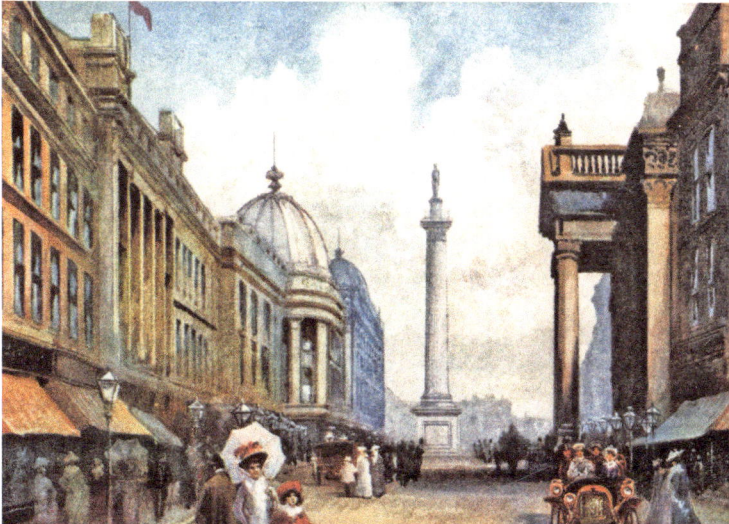

Grey's Monument and Grey Street.

for Northumberland from 1786 to 1834. He was prime minister from 1830 to 1834 and in that time the Great Reform Act was passed, in 1832, which gave the vote to a larger part of the population. He was also a great anti-slavery supporter and slavery was banned in the British Empire in 1833. The monument was erected to him in recognition of his political achievements not for the special blend of tea that includes bergamot to counteract the harsh waters near Howick. His wife used to serve guests with the tea in London when he was prime minister and a tea maker then went on to produce it commercially, but Earl Grey himself did not benefit financially from this. His career started in controversy as he had an affair with the Duchess of Devonshire and had a child with her (the film *The Duchess* in 2008 features this episode). His family adopted the child. He then got married and his daughter was brought up with his other fifteen children he had with his wife Mary. Grey's Monument on Grey Street was opened in 1838 and was designed by Benjamin Green. Newcastle City Guides offer the public the opportunity to climb the 164 steps to the top for an unusual view of the city. Opening times can be found on the guide's website www.newcastlecityguides.org.uk.

Grundy, John

TV presenter John Grundy has a great enthusiasm for historic architecture in the North East and Newcastle in particular, having published a book on the history of Newcastle in 2016. His interest was developed during his time working as listed buildings inspector when he travelled throughout the north looking for historic buildings that needed statutory protection. His quirky and humorous commentary during his programmes has led to him becoming a popular advocate for celebrating the historic built environment in the North East.

Guildhall

The present Guildhall has changed considerably over the years and almost all of Newcastle's famous architects have left their mark on the building. It started as the Exchange building first erected in 1655 on the site of an earlier building, designed by Robert Trollope. It was altered by William Newton and David Anderson between 1794 and 1809 and finally by John Dobson in 1825. It served as the town hall, courthouse and meeting rooms for the Merchant Venturers. Many original features are preserved including the 1658 Town Court, Mayor's Parlour and Merchant Venturers' Court.

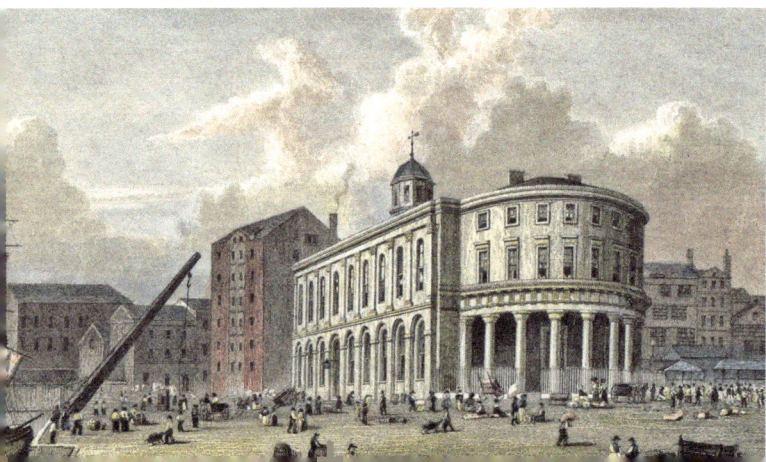

Guildhall, c. 1829.

H

Hadaway, Tom

Born and bred in North Shields, Tom Hadaway was a local playwright best known for writing some of the early episodes of the acclaimed *When the Boat Comes In* television series aired in the 1970s. He also wrote *God Bless Thee Jackie Maddison* for TV in 1974. Locally he was a very influential at the Live Theatre and his plays are still being performed today by local actors in various venues.

Hadrian's Wall

The Roman wall built by Roman Emperor Hadrian in AD 122 originally terminated at Newcastle, underneath the present castle. It was extended to Wallsend four years later, to a more appropriately named town. The wall follows a straight line west from the castle, which was built on the site of a Roman fort, parallel to Westgate Road and West Road that follow the original line of the wall. The remains of the original wall lie under the present buildings and streets and it has been excavated a few times along this route. The most notable finds were at the Mining Institute and the Newcastle Arts Centre where a milecastle was also discovered. There was a Roman fort at Benwell called Condercum but this is now covered in buildings. The first sections of Hadrian's Wall that can be seen above ground are on West Road either side of the Western Bypass.

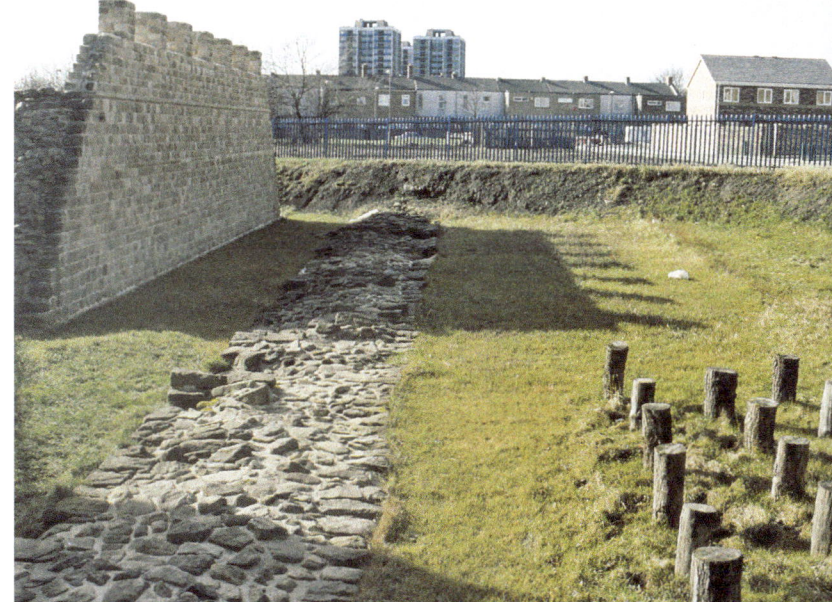

Replica beside original Hadrian's Wall in Wallsend, Segedunum Museum.

A–Z of Newcastle

Hadrian's Way

The long distance walking route known as Hadrian's Way passes along the riverside and along the Quayside stretching from Segedunum Roman Fort in Wallsend to Bowness on Solway, a distance of over 73 miles or 80 Roman miles.

Hair, Thomas Harrison

Despite having his paintings displayed at the Royal Society, Thomas Harrison Hair (1808–75) is best remembered for recording the many collieries of the northern coalfields in the mid-nineteenth century. This unique record of the world's premier coalfield was recorded mainly between 1838 and 1844 shortly before many of the collieries were flooded, abandoned and demolished. Thomas was born in Newcastle and probably learnt his trade as an apprentice to a local engraver Mark Lambert, a former assistant to Thomas Bewick. Many of his works are held at the Hatton Gallery in Newcastle.

Halfpenny, Jill

Local actress Jill Halfpenny is famous for appearing on TV in many roles, starting with *Byker Grove* as well as winning *Strictly Come Dancing* in 2004. She took a leading part in the major celebrations to celebrate the 1 millionth Great North runner in 2014. She stood on a ladder on the Millennium Bridge dressed as a medieval noblewoman in a very long dress reading the history of North East England.

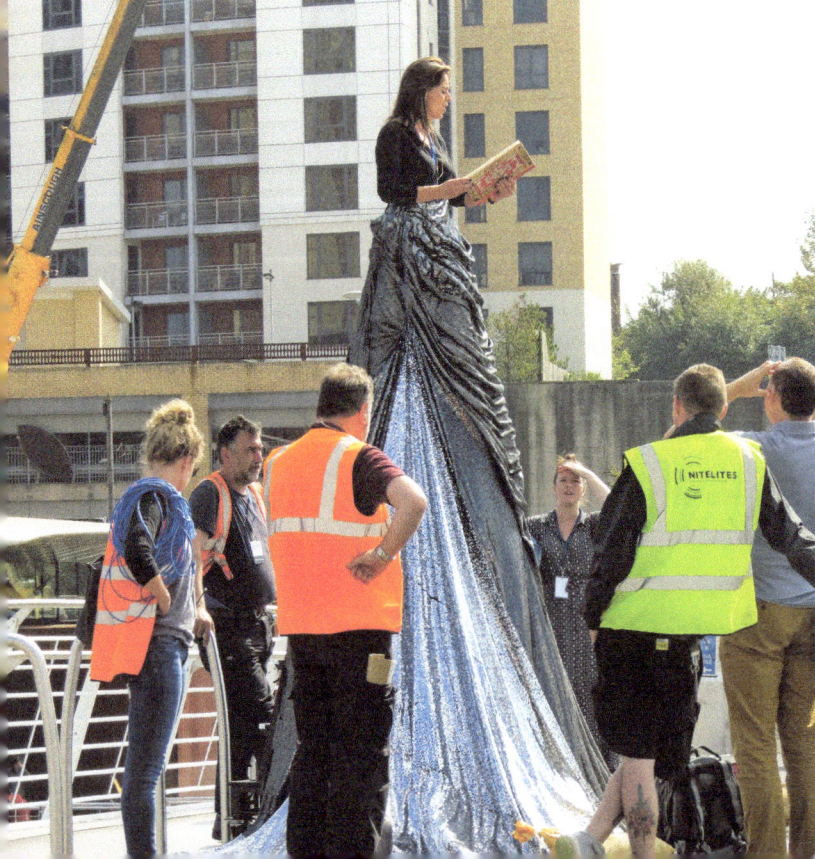

Jill Halfpenny on the Millennium Bridge.

H

Hall, Sir John

Sir John Hall built the Metro Centre at Gateshead in 1983. He then became owner and chairman of Newcastle United with Freddy Shepherd from 1992 to 2007. He was responsible for rebuilding St James' Park and now has a stand named after him. During his time as owner Newcastle United almost won the Premier League in 1996, and under manager Kevin Keegan were known as 'the entertainers'. Sir John also tried to establish a sporting club in Newcastle similar to that at Barcelona and he set up Newcastle Falcons Rugby Club, Newcastle Eagles basketball team and an ice-skating team called Newcastle Cobras. (*See* page 12 for mural.)

Hall, Lee

Famous for writing the film and musical *Billy Elliot*, Lee Hall has also written a number of plays for local theatre including the *Pitman Painters*, which eventually ended up on Broadway. He was born in Newcastle in 1958, went to Benfield School in Walkergate and got interested in theatre through Wallsend Arts Centre. He then went to Fitzwilliam College, Cambridge, before becoming a screenwriter and playwright.

Hardwick, Charlie

Former *Emmerdale* actress Charlie Hardwick was born in Wallsend and starred in *Byker Grove*, *Purely Belter* and *Billy Elliot*. She has been a great supporter of local theatres including appearing in Sting's musical *The Last Ship* at Northern Stage in March 2018.

Harvey, Joe

The last Newcastle United manager to win a meaningful trophy is Joe Harvey, who won the European Inter Cities Fairs Cup in 1969. He was also a player and captain of Newcastle in 1951 and 1952 and a coach in 1955 when they won the FA Cup, the last domestic trophies won by the team. A plaque to him was erected and unveiled on the Gallowgate End wall of St James' Park in 2014 to recognise his achievements.

Hatton Gallery

Situated within the campus of Newcastle University and with links to the Fine Arts department, the Hatton Gallery has recently been extended and refurbished. Its most famous work is a wall taken from the *Merzbarn* by the German artist Kurt Schwitters. This was rescued from Ambleside in the Lake District and erected in the gallery in 1965 and remains on display today.

Healy, Brendan

The Newcastle comedian Brendan Healey died in 2016 and will be remembered for his unstinted support for the Sunday for Sammy concerts held every second year in Newcastle in memory of Sammy Johnson and to support local talent in the North East. He had a wide range of talents including as a stand-up comedian, an actor in local Catherine Cookson films, and a producer of pantomimes at the Tyne Theatre, as well as being a writer. (*See* page 12 for mural.)

Healy, Tim

After gaining national fame in *Auf Wiedersehen, Pet* as Dennis, Newcastle-born Tim Healy has had a long and varied television career in a number of different roles. He has never forgotten his roots and has supported local actors and theatres all his life, especially Live Theatre where he started his acting career. He is also one of the hosts of the Sunday for Sammy concerts. He was married to Denise Welch for many years and they had a son, Matthew, together. In 2014 as part of the Great North Run One Million Runners celebration he narrated, with Jill Halfpenny, the history of North East England as part of a spectacular opening ceremony on the Quayside.

Higgs, Professor Peter

The British theoretical physicist Professor Peter Higgs was born in Elswick in 1929. His father worked as a sound engineer for the BBC and moved around the country and he did not stop long in Newcastle. Peter went to school in Bristol and took his degrees and PhD in London. He became a university research scientist and is famously known for predicting the existence of a new particle known as the Higgs Boson, which was later confirmed in 2013. He has received a wide range of national and international honours for his work.

High Level Bridge

Queen Victoria officially opened the High Level Bridge on 28 September 1849 as she returned from Scotland with Albert. The bridge had been in use for over a month before this, and for the first time passengers travelling over the Tyne did not have to get off at Gateshead and cross the bridge on foot to catch a train in Newcastle to continue a journey north. The bridge was the first in the world to have two levels, carrying a railway above and a roadway beneath. It was designed by Robert Stephenson and Thomas Harrison and the road deck opened later in 1850. The road bridge originally had a toll when it first opened.

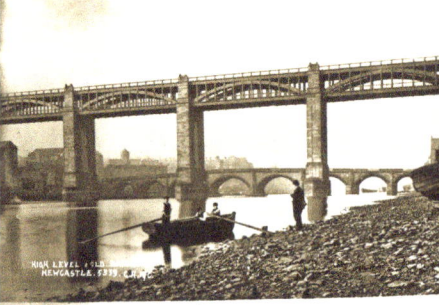

High Level Bridge, *c.* 1864 and 2014.

Holland, Jules

The 1980s cult live music TV show *The Tube* was set in Newcastle at the old Tyne Tees Television Studios on City Road and was named after the covered entrance that looked like a tube. The presenters of the show were Jules Holland and Paula Yates. It launched both of their careers, as well as bands such as Frankie Goes to Hollywood and The Proclaimers.

Hoppings, Town Moor

The Hoppings on the Town Moor is one of the biggest travelling fairs in Europe and has traditionally been held each year during Race Week in the last week of June. It started in 1882 as a temperance fair for working men and their families as an alternative to drinking and gambling at the horse-racing events held that week culminating in the Pitman's Derby the Northumberland Plate. There are a number of explanations for why it got its name, such as after people dancing, but I prefer the one that refers to early fairground workers wearing flea-infested clothes and hence did a lot of hopping around.

Holy Jesus Hospital

Built on the site of a former Augustinian friary, the Holy Jesus Hospital was opened in 1681 for elderly and poor freemen of Newcastle and their families. An extension was built onto the building in 1880 and opened as a soup kitchen, as seen on the sign overlooking the central motorway that was built in the 1960s only metres away from the ancient building. The hospital was used for housing until 1937, then as a museum and now as offices.

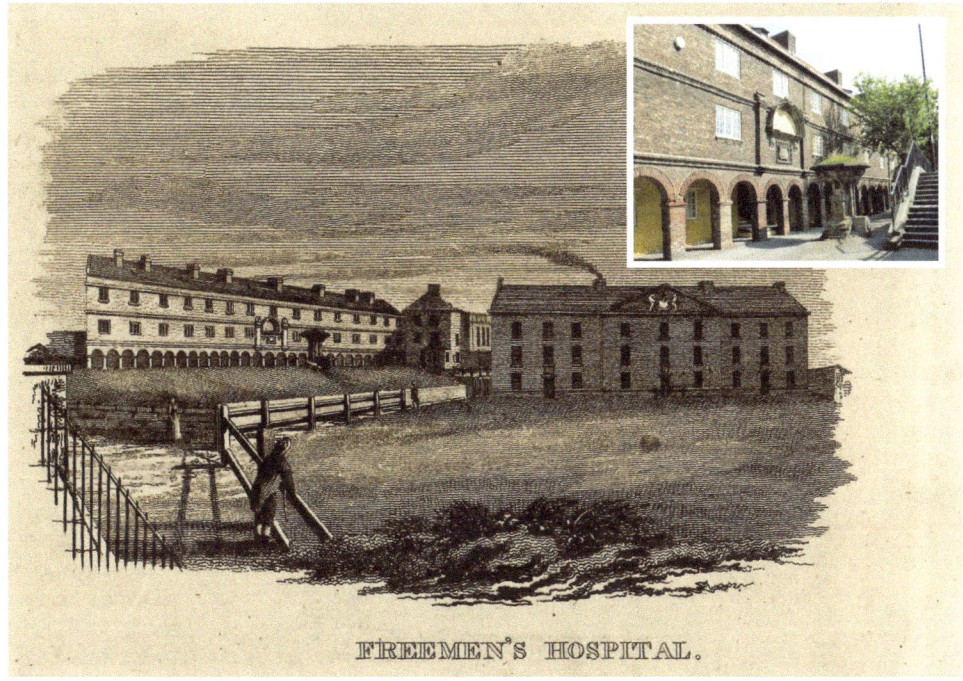

Holy Jesus Hospital, City Road, *c.* 1700 and 2014.

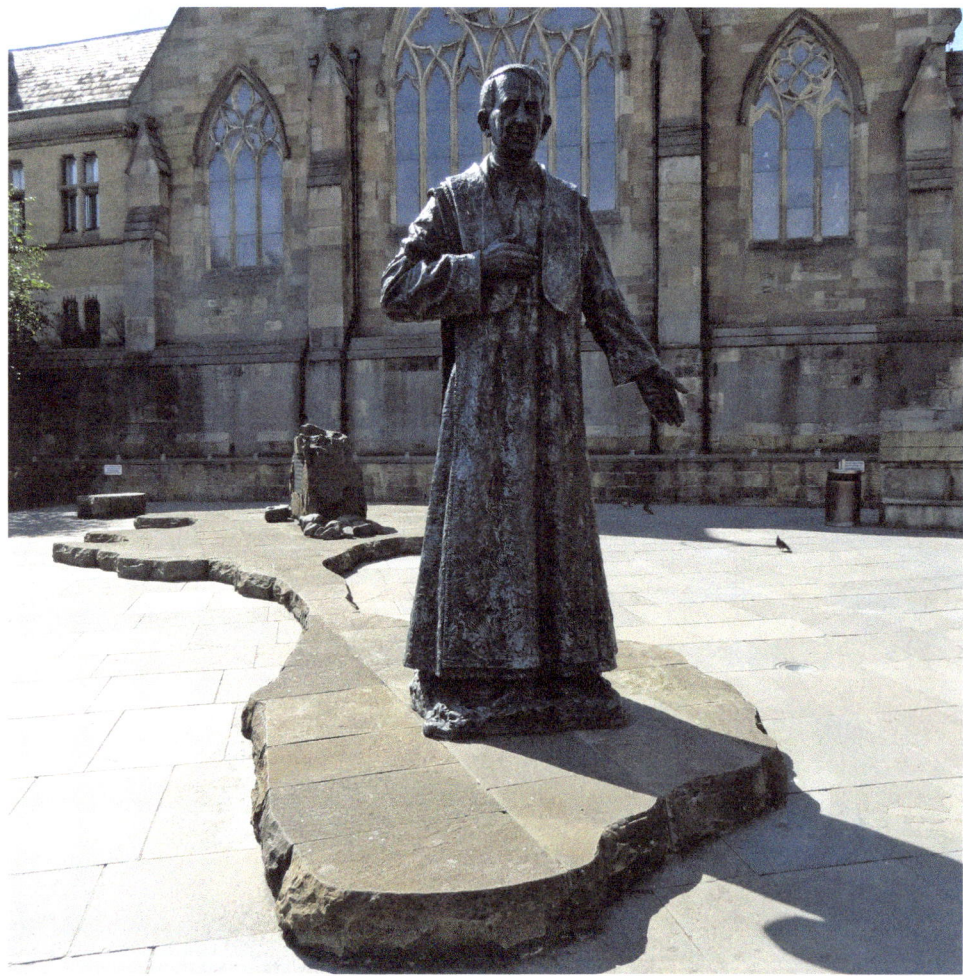

Cardinal Basil Hume, St Mary's Cathedral, Neville Street.

Hume, Basil

Cardinal Basil Hume was born as George Hume in 1923 at No. 4 Ellison Place, Newcastle, and went on to become Cardinal Archbishop of Westminster, the head of the Catholic Church in England. His statue stands in a memorial garden to the rear of St Mary's Cathedral and was unveiled by the Queen in 2002. He is seen standing on a representation of the holy island of Lindisfarne, beside boulders taken from the island, where St Cuthbert and St Aidan had lived. (*See* mural on page 54.)

I

Infirmary

Newcastle's first infirmary was built in 1752 on the area known as the Forth, now the site of 'Life'. Following the building of the nearby Central railway station on one side and the Cattle Market on the other, conditions in the infirmary deteriorated for patients and a new site was proposed on the Town Moor. The Royal Victoria Infirmary (RVI) was opened in 1906 as the new infirmary.

Infirmary, Forth Street, c. 1770.

Institute of Mining and Mechanical Engineers, Neville Street.

Institute of Mining and Mechanical Engineers

The Mining Institute, as it is usually referred to as, was established in 1852 by mine owners and engineers to oversee safety and improvements in mining practices in the North East. The building itself, which is currently under restoration, dates from 1872 and holds extensive mining records and also has an impressive library and lecture theatre.

Ingham, Robert

Robert Ingham, MP for South Shields between 1832 and 1841 and 1852 and 1868, was born in Newcastle in 1793. The Ingham Infirmary in South Shields was opened in 1873 and was named after him. It closed in 1990.

International Airport

Newcastle International airport is the North East's main airport dealing with over 5 million customers each year and flying to over 100 destinations. It is situated 5 miles north-west of the city centre and is linked directly to Newcastle city centre by the Metro rapid transit system.

J

Javel Groupe

One of the most unusual street names in Newcastle only survives as a street name erected on a plinth on the roundabout below the High Level Bridge. All trace of the medieval street that survived until the 1930s have disappeared under roadworks. It got its name from 'gavell', which referred to the king's gaol in the castle, and 'groupe', which referred to a stream or channel.

Jesmond Old Cemetery

If you were rich in the nineteenth century you could choose to be buried with a higher class of people in Jesmond Old Cemetery. It opened in 1836 and was designed by John Dobson, who ultimately was laid to rest there with former mayors, shop owners, shipowners and local gentry. The Friends of Jesmond Cemetery have done an excellent job of restoring the graveyard and along with the Newcastle City Guides give guided tours of the cemetery on a regular basis.

Johnson, Brian

The former lead singer of AC/DC comes from Dunston in Gateshead and is a great fan of Newcastle United. His first band Geordie was formed in Newcastle in 1971 and had success in Britain. In 1980 he was asked to join AC/DC after the death of their lead singer Bon Scott. After decades of leading the rock band all over the world, including being inducted into the Rock and Roll Hall of Fame in 2003, he was advised to give up performing in 2016 after developing serious hearing problems that could lead to him going deaf. (*See* page 10 for mural.)

Javel Groupe, The Close, Quayside..

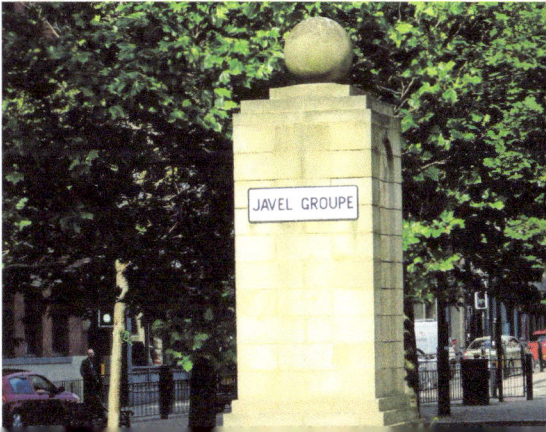

K

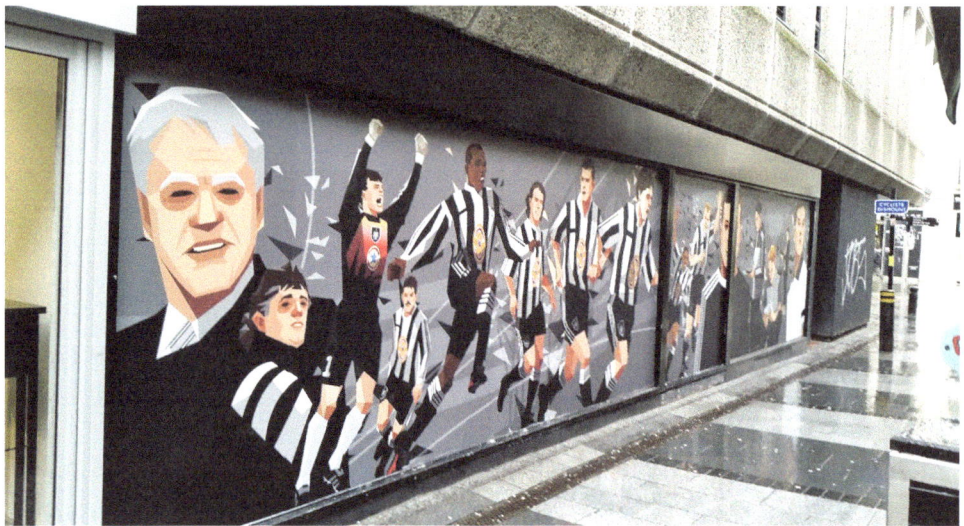

Kevin Keegan (second from left) on the mural off Queens Square.

Kevin Keegan

He was once called the 'Messiah' for saving Newcastle United from sinking into the third tier of football when he took over as manager in 1992. Kevin Keegan then went on to gain promotion to the Premier League and his team, known as the 'Entertainers', almost won the league in 1996. He had three spells at the club, first as a player when in his second season he helped the team gain promotion to league 1 in 1984. His last stint ended in disappointment as he walked away from the club in 2008 in protest at not being in control of transfers and the team were relegated in 2009.

Keelman's Hospital

The Keelman's Hospital was built in 1701 in Sandgate, the area occupied by Keelmen for centuries. It was paid for by the keelmen themselves by donating part of their wages, which at the time was very unusual for working men to do. It was built to house elderly and sick keelmen and their families. The keelmen used their flat-bottomed boats or keels to transport goods, mainly coal, from places up river to waiting ships near the mouth of the Tyne. They were one of the few vessels that could pass under the low arches of the

K

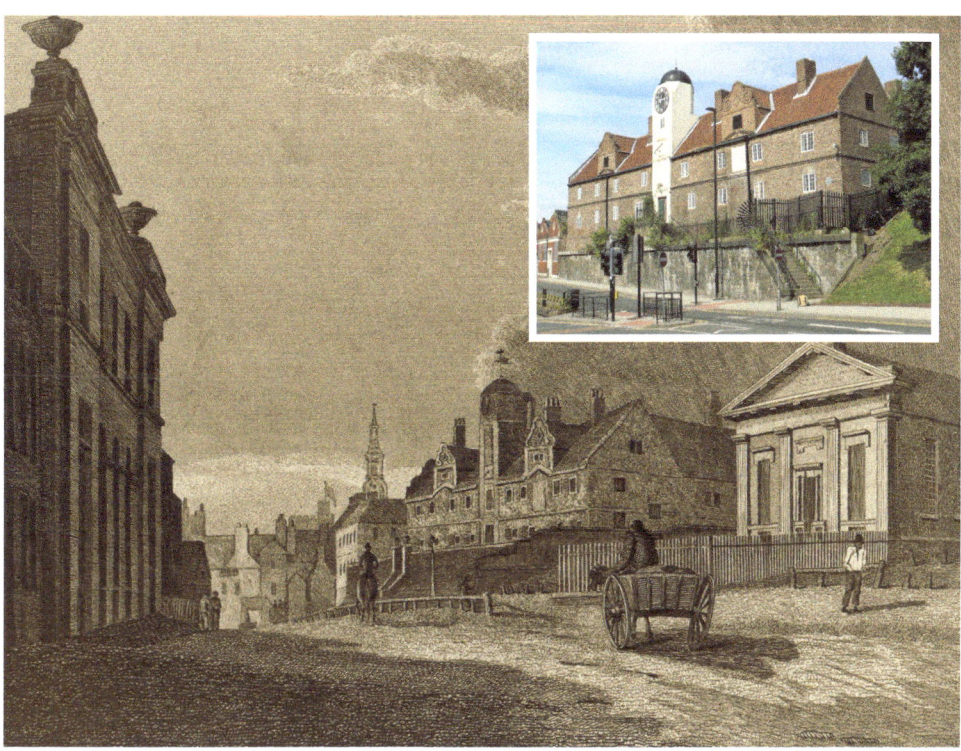

Keelman's Hospital, *c.* 1820 and 2014.

Medieval and Georgian bridges as their sail could be lowered. When the Swing Bridge was opened in 1876 the keelmen lost most of their trade. The building was used until 1937 and was later converted into student accommodation, but at present it is vacant.

King Charles I

Between 13 May 1646 and 3 February 1647 Charles I was kept prisoner in Newcastle as the Scots controlled the town in league with Parliamentary forces. He did not exactly have an uncomfortable stay as he was not put in one of the two prisons in town, but was housed in the biggest mansion within the town walls, called Anderson Place or Newe House. In his spare time he was reputedly allowed to play golf on the fields at Shieldfield as well as drink at a local hostelry, which is now called the Old George off the Cloth Market where the seat he sat in has allegedly been preserved.

King Edward VII Bridge

The second rail bridge to cross the Tyne, after the High Level Bridge, was opened by Edward VII on 10 July 1906 and was named after him. When it was opened to traffic on 1 October 1906, it was now possible for trains crossing the river to pass through Central station without having to reverse out again – there had been only one river crossing up to that time. It was designed by Charles Augustus Harrison, the nephew of the designer of the High Level Bridge Thomas Elliot Harrison, and built by Cleveland Bridge Co.

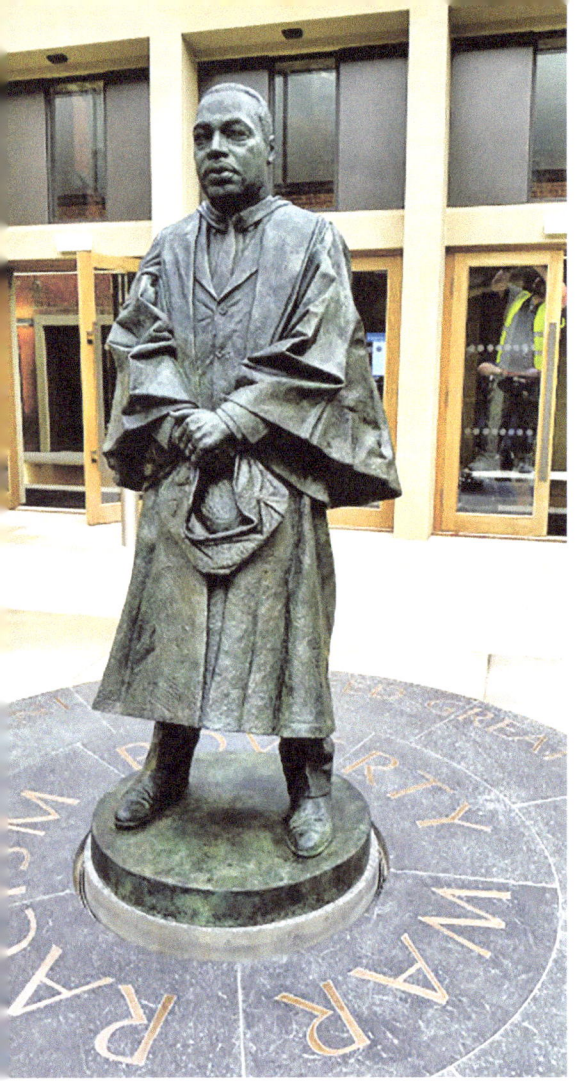

Martin Luther King statue, Armstrong Building Courtyard, Newcastle University.

King, Martin Luther

A statue to Martin Luther King was unveiled on 13 November 2017 to commemorate fifty years since his visit to Newcastle to receive an honorary degree for his work in promoting racial equality, peace and tackling poverty in the world. It is situated on the Newcastle University campus in the courtyard of the King's Hall close to where he received the award only five months before he died. Newcastle was the first and only British university to bestow such an honour on him.

Knopfler, Mark

The Dire Straits lead guitarist Mark Knopfler went to school in Newcastle before becoming world famous after founding his band in 1977 with younger brother David. The band broke up in 1995. He is remembered in Whitley Bay for writing a song about the Spanish City fairground, and some of the words are etched into a wall beside the dome of the Spanish City. His song 'Local Hero' is also played at each home game of Newcastle United.

L

La Frenais, Ian, and Dick Clements

The famous writing partnership of Ian La Frenais, who went to school in Newcastle, and Dick Clements will always be remembered for writing the television hits *The Likely Lads* and *Auf Wiedersehen, Pet*. Both have strong links with Tyneside.

Laing Art Gallery

The Laing Art Gallery was founded in 1904 by John Laing, a local wine merchant who paid for the building, donated it to the city and asked others to provide the art collection. The building is now operated by Tyne & Wear Archives and Museums and is free to enter. It now has an extensive art collection featuring works by John Martin, Sir Joshua Reynolds, J. M. W. Turner and local artists Ralph Hedley and James Wilson Carmichael. There is also a collection of the famous enamelled glasswork of William Beilby and many important pieces of locally made Maling pottery.

Library

Newcastle Central Library is now in its third building on this site in New Bridge Street. The first Free Library was built in 1880 and originally was joined physically to the Laing Art Gallery. John Dobson Street was then built through the site of the library and the Basil Spence-designed concrete ribbed library was constructed on the west side of the road and opened in 1968. The present library was opened in 2009 on six floors and continues to be a popular, well-used resource for residents and visitors.

Laing Art Gallery and Library, *c*. 1900 and 2014.

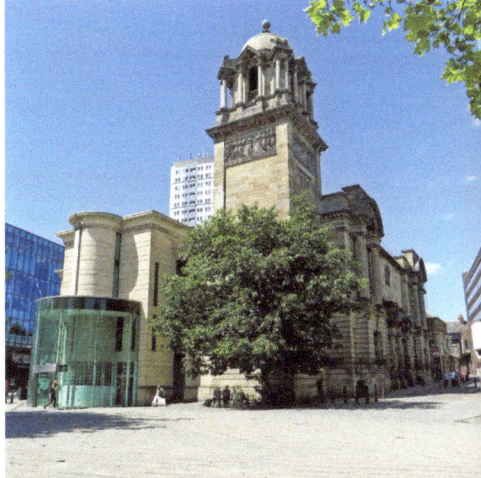

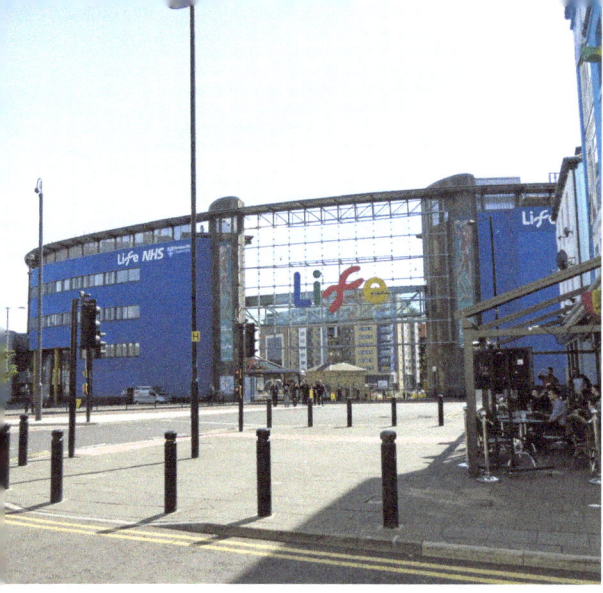
Life, Times Square.

Life

The Life Science Centre is an interactive museum and educational establishment linked to the International Centre for Life, a research facility promoting the advancement of the life sciences, both of which are based in Times Square. The centre was opened by the Queen in 2000 and now has 600 people from the private sector and local universities working on the site. Work undertaken is involved in genetics, fertility, stem cell research and many other complex fields of research. Regular events are held in the central square that once housed a cattle market.

Lindisfarne

The 1970s pop group Lindisfarne originated in Newcastle and their famous Tyneside anthem 'Fog on the Tyne' was sung religiously every Christmas at their legendary Christmas concerts held in the City Hall.

Literary and Philosophical Society

The Lit & Phil is one of the oldest societies of its type in the country and was established in 1793 as a conversation club when talk about politics and religion was banned. The present building was built on Westgate Road in 1825, and it was here in 1880 that Joseph Swan demonstrated the first incandescent light bulb in the world. The building also houses an impressive library. The society was always forward thinking and welcomed women to join as early as 1804. In 2011 they invited Alexander Armstrong to become president.

Live Theatre

Based in Broad Chare on the Quayside since 1982, the Live Theatre is a small local theatre established in 1973 by Val McLane (sister of Jimmy Nail) and others as a touring company for local actors and artists. It has helped many famous Tyneside actors to go on to have successful careers including Tim Healy, Robson Green and Val herself. Many famous writers have contributed to Live Theatre including Tom Hadaway, Alan Plater, Peter Flannery and Michael Chaplin.

M

Mcleod, Mike

The winner of the first two Great North Runs was Mike Mcleod, known as the 'Elswick Express' as he ran for Elswick Harriers club. He won an Olympic silver medal in the 10,000 metres at the 1984 Games in Los Angeles and represented Great Britain on a number of occasions.

Macdonald, Malcolm

'Supermac', as he is known to his fans on Tyneside, was a famous centre forward for Newcastle United in the 1970s. He became a legend after scoring a hat-trick against Liverpool on his home debut and later scoring five goals against Cyprus playing for England. He even opened his own men's fashion shop in Newcastle, something never seen before. Following a serious injury he retired early and had a career in football management. He then returned to the North East to work on local radio and as a sports writer for local newspapers.

Mcelderry, Joe

Having got his big break on a talent show, Joe McElderry from South Shields, who studied performing arts at Newcastle College, has become a well-established and successful celebrity. Joe won the sixth series of *X Factor* in 2003 and has since had five top-20 albums and recently appeared as Joseph in *Joseph and his Amazing Technicolour Dreamcoat* in a national tour.

Mckinnell, Catherine, MP for Newcastle North

Catherine Mckinnell was born in Denton and went to school in Fenham. She studied politics and history at the Univesity of Edinburgh and became a solicitor working in employment law for a Newcastle legal firm. She became Labour MP for Newcastle North in 2010 and was later Solicitor General from 2015 to 2016 before resigning from the post.

McCracken, Esther

Esther McCracken (1902–71) was a famous playwright and film star who was born in Newcastle and later married Mungo Campbell, a successful businessman. From 1940 to 1956 she presented a BBC radio programme called *Wot Cheor Geordie* that had the signature tune 'wherever ye gaan, you're sure to meet a Geordie'. They bequeathed the money to set up MEA House as a centre for charities and other voluntary organisations

in Newcastle. It was named after the three original trustees who set up the MEA Trust in 1967. M stands for Mungo, E refers to Esther and A is for Alistair Fyfe, a solicitor. MEA House was opened by the Queen in 1974.

Malia, Carol

Carol Malia took over from Mike Neville as the main presenter on *BBC Look North* in 1997 and has proved to be a popular choice with the public. Carol grew up in Cullercoats, studied journalism in Darlington and worked first as a journalist in Hartlepool. She then worked on local radio in Cumbria before starting on TV with Border TV then on Tyne Tees Television before moving to the BBC to work with Mike Neville.

Man with Potential Selves

This artwork by Sean Henry is made up of three life-sized figures of the same man on Grainger Street between Westgate Road and Neville Street. One stands close to Westgate Road looking south at himself striding towards him. The third figure and the main talking point is seen lying in a horizontal position balanced on his right elbow on a wall close to the Metro station entrance.

Marks & Spencer Penny Bazaar

The oldest Marks & Spencer store in Britain is in Newcastle Grainger Market. It opened in 1895 as a Penny Bazaar selling goods for one penny and you could even get free admittance to the store as it still says on the sign in the shop. It presently sells end of line clothes and other goods. It was not the first Marks & Spencer store as that

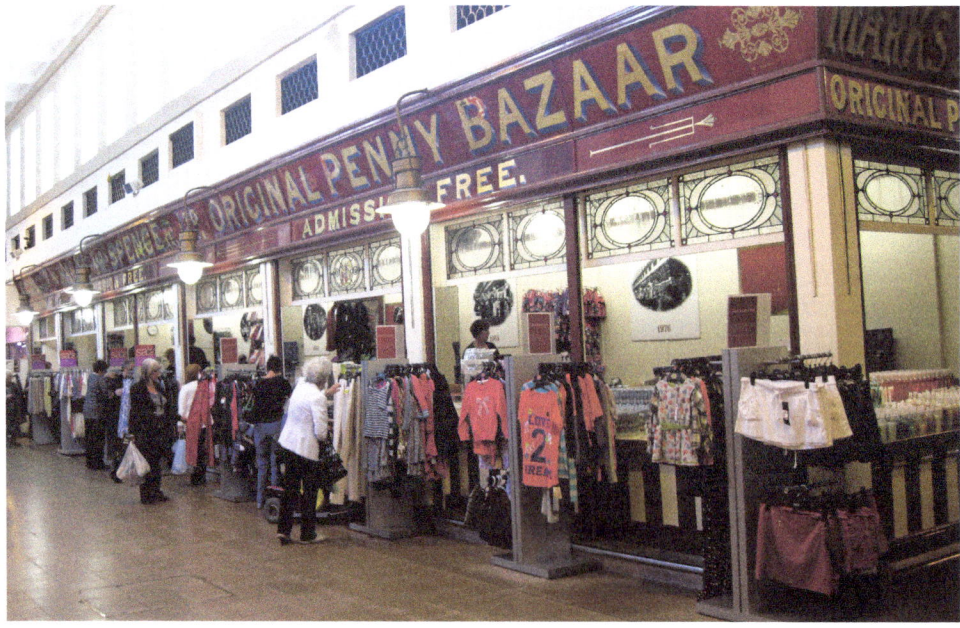

Marks & Spencer Penny Bazaar, Grainger Market, Grainger Street.

was in Leeds and was opened in 1894, but that closed some years ago. Michael Marks was a Polish Jew living as a refugee in the Russian Empire who came to Leeds in 1884 and met Thomas Spencer, a cashier.

Marley, Sir John

A statue of Sir John Marley (1590–1673) can be found on Northumberland Street above a shop close to Fenwick store. He was Mayor of Newcastle during the Civil War in the 1640s and saved St Nicholas' Church's famous lantern tower by putting Scottish prisoners in the church when the besieging Scottish army threatened to fire cannonballs at it.

Medieval Bridge

The medieval bridge replaced the earlier Roman Bridge built around AD 122 by Emperor Hadrian at the same time he built his famous wall. It is thought the medieval bridge was built after 1248 following a major fire on the earlier bridge that was thought to have timber decking. The Roman Bridge could have been rebuilt after 1171 as the dedication of the chapel to St Thomas à Beckett at the end of the bridge was thought to have been erected at that time. The stone-built medieval bridge had many structures built on it including towers, shops, houses, chapels and even a gaol. On the south side of the bridge at one time it had a drawbridge, gate and portcullis and it was referred to as the gate's head. The middle tower also had a portcullis and was used as a prison. The northern tower was known as the magazine tower as it stored gunpowder. The bridge survived for over 500 years until 1771 when the Great Flood swept away large sections of the bridge with the loss of six lives. It took ten years to replace it.

Medieval bridge on the site of the Swing Bridge.

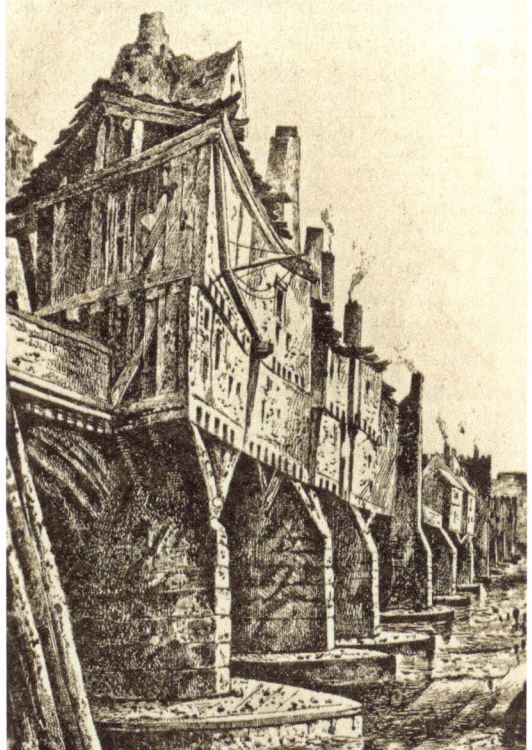

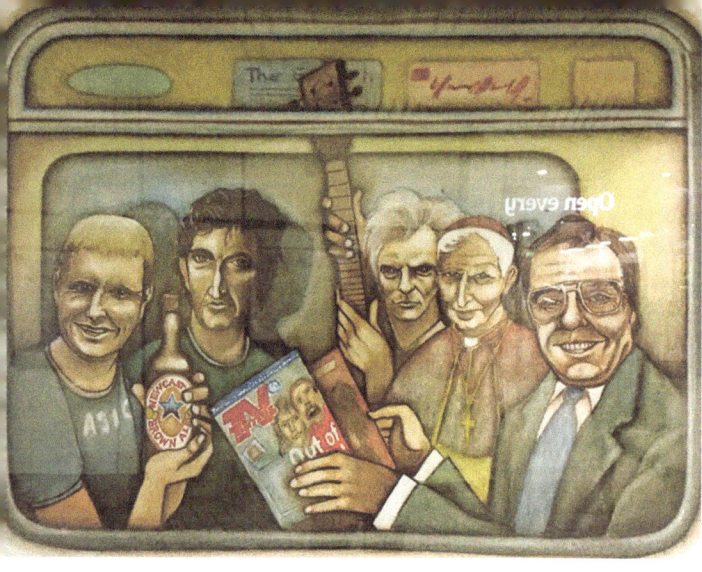

From left to right: Gazza, Jimmy Nail, Sting, Basil Hume, Mike Neville. Monument Metro station.

Metro

The fast way to travel around Tyneside, the coast and as far as Sunderland or Newcastle Airport is to use the Metro. The rapid-transit system was opened in the early 1980s and has a number of underground stations in the centre of Newcastle. Monument station, built under Grey's Monument, is situated in the city centre and is a main interchange between trains travelling north–south and east–west. Like a number of Metro stations, it has artworks on the concourse and at Monument station are some murals depicting local heroes travelling on the Metro. The people featured are Alan Shearer, Brian Johnson, Brendan Foster, Rowan Atkinson (as Blackadder), Sir John Hall, Peter Beardsley, Dame Catherine Cookson, Tim Healey, Jack Charlton, Paul Gascoigne (Gazza), Jimmy Nail, Sting, Cardinal Basil Hume and Mike Neville.

Metro Centre

Situated in Gateshead a few miles inland and adjoining the A1, the large Metro Centre shopping and retail park was developed by Sir John Hall in the 1980s. When it was built it was one of the newest and largest out-of-town shopping centres in Europe and is still a major retail attraction in the area.

Milburn, Jackie

Three-time FA Cup winner Jackie Milburn (1921–87), or 'Wor Jackie', hails from Ashington and was Newcastle United's record goalscorer before Alan Shearer. He played for the club from 1943 to 1957 and played fifteen games for England, before becoming a well-respected local journalist. A statue to him was erected outside St James' Park in 1991.

Millennium Bridge, Gateshead

The Gateshead Millennium Bridge was opened by the Queen on 2 May 2002. It had been constructed in Wallsend and was carried along the river by a giant water crane and put in place on 20 November 2000. It is known as 'the blinking-eye bridge' as it can tip to allow vessels to pass beneath it with the same clearance as the Tyne Bridge. It was designed as a foot and cycle bridge linking the Baltic and Sage to the Newcastle Quayside and was the developed by Gateshead Council, which is why it got its name.

River God at the Baltic Centre, and Millennium Bridge.

Miller, Stephen

Stephen Miller from Cramlington, a former student at the Northumbria University, is one of the most successful Paralympians for Great Britain. In his discipline of club throwing he won three Paralympic golds, one silver and one bronze medal from 1996 to 2016. He also won a bronze medal in the discus in 2000.

Millican, Sarah

Well-known TV personality and comedian from South Shields Sarah Millican had appeared many times in Newcastle doing her stand-up routine before she became famous. She was voted the most promising newcomer at the Edinburgh Festival Fringe in 2008 and went on to have her own TV shows. She now travels around the country doing sell-out stand-up tours. She married fellow comedian Gary Delaney in 2013.

Monkchester

Between the Roman and Norman occupations of Newcastle little is known about life in the present city. It is thought a Saxon settlement was established in the area of the former Roman fort known as Monkchester. Archaeological evidence has revealed the remains of a small chapel (under the railway arches) and a large number of Christian burials in this area. An early monastic settlement on the site probably led to it being called Monkchester, but as the settlement was probably not built in stone and the Normans built their castle on the site, little evidence remains of this period of history. The name is recorded in a mural dating from 1974 by Henry and Joyce Collins on the side of the Primark shop on Northumberland Road.

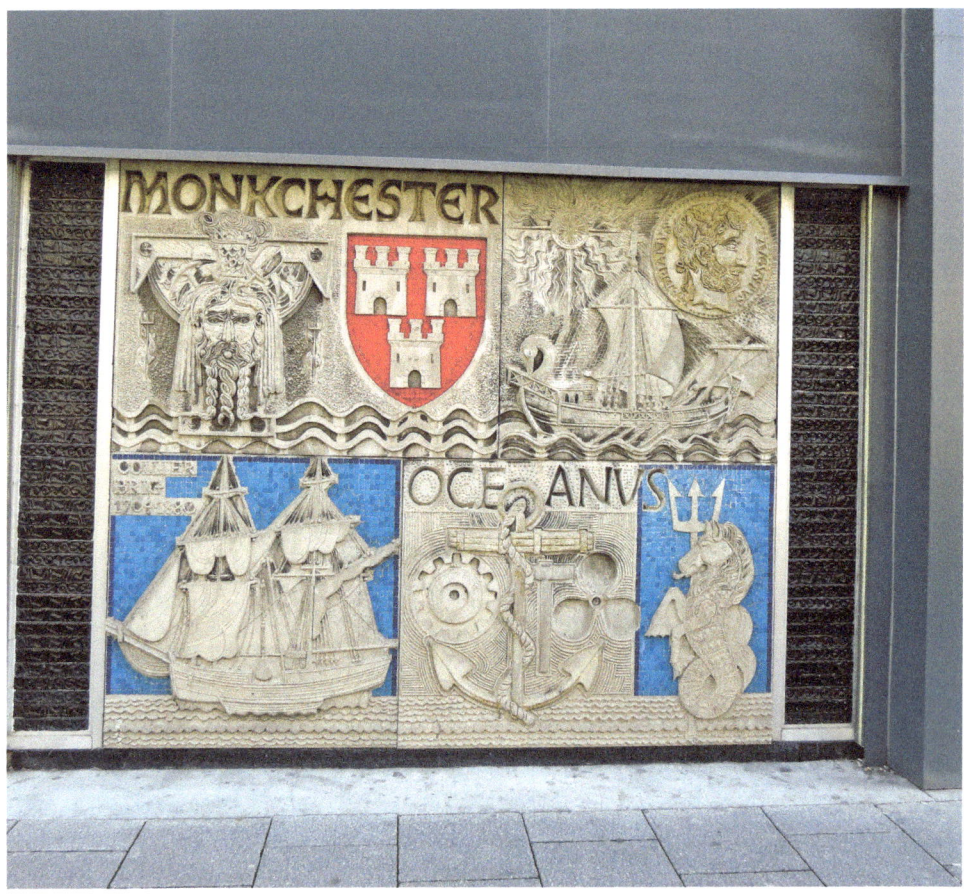

Monkchester, mural on Northumberland Road.

Moot Hall

The Moot Hall was erected in 1810 to replace the earlier Moot Hall on the site of the Vermont Hotel. It was built as the county court for Northumberland and is still used as a Crown Court on an occasional basis.

Mosley Street

Mosley Street was built in 1784 and named after Alderman Mosley, who contributed to its costs. The street linked Dean Street to Pilgrim Street and in 1818 became the first street in the town to be lit by gas lamps. In 1881 it was the first street in the country to be lit by electric light bulbs.

Nail, Jimmy

Brother of Val McLane, who founded the Live Theatre, Jimmy Nail (or James Michael Aloysius Bradford) is well known for his television appearances as Oz in *Auf Wiedersehen, Pet* and wrote and played the lead in *Spender* and *Crocodile Shoes*. He also appeared in *Evita* with Madonna and appeared on Broadway in the play *The Last Ship* written by Sting. His first love was music and he had a number of successful recordings including *Crocodile Shoes*. (*See* page 54 for mural.)

Neville, Mike

Born as James Armstrong Briggs in Willington Quay, Mike Neville (1936–2017) went on to be a much-loved TV presenter on local news programmes. After a short acting career he started work as a presenter at Tyne Tees Television, He then moved to the BBC to be the anchor for *Look North* for forty-two years and later went back to the commercial channel. He was also a great promoter of 'Geordie culture' through his partnership with co-presenter George House. They presented a regular sketch on TV called 'Larn Yersel Geordie' where they tried to educate the public on how to talk 'proper Geordie', which was a bit ironic as Mike himself as a presenter had lost his own Geordie accent through elocution lessons early in his career. (*See* page 54 for mural.)

Neville Street

The street was named after the Neville family who had lived in Westmoreland House, which was on the site of the present Mining Institute.

Newcastle Breweries and Brown Ale

Newcastle Breweries operated in Newcastle from 1890 to 2005 and had a large site to the west of St James' Park, which is now being developed as Science Central or Helix. Their most famous product was Newcastle Brown Ale or 'The Dog', which has been exported worldwide and was brewed in Tadcaster in Yorkshire from 2007 until 2017, when it moved to Holland.

Newcastle Coast

Technically Newcastle is not on the coastline as it is 8 miles inland but for marketing purposes the term 'Newcastle coast' has been used to sell the attractions of the city to potential visitors. The seaside towns of Tynemouth, Cullercoats, Whitley Bay and

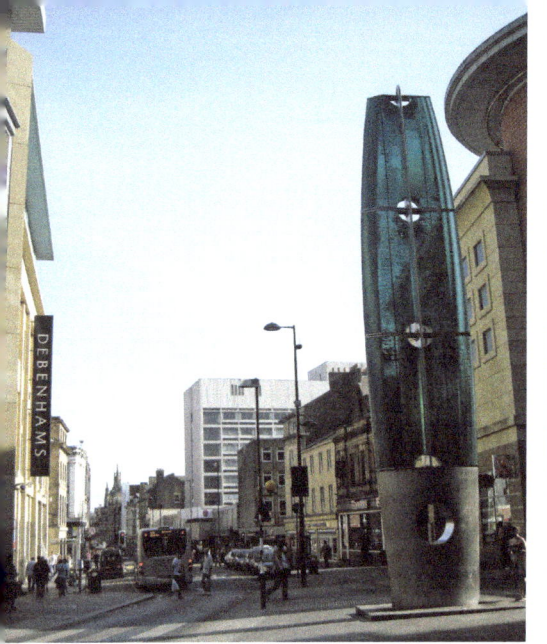
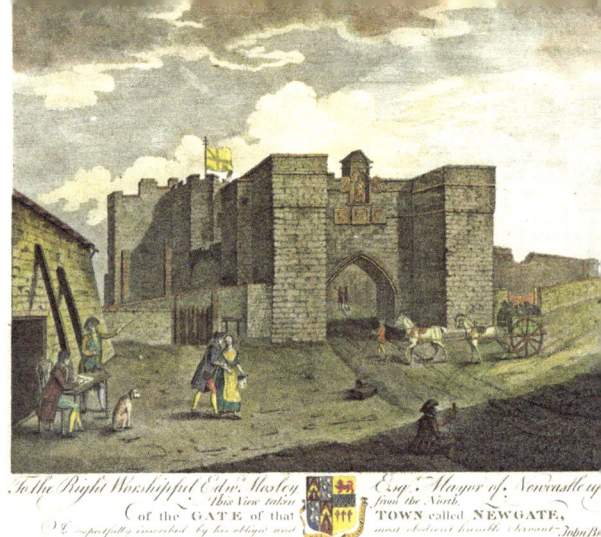

Newgate Street and the Newgate in 1781.

South Shields can be reached within thirty minutes using the Metro and the attractive Northumberland coastline, an Area of Outstanding Natural Beauty, is only a short drive away.

Newgate Street

Newgate Street at one time led from the Bigg Market to the Newgate in the town walls. Newgate was a large gate with a bastion to the north and it was used as the town gaol from the fifteenth century until it was pulled down in 1823.

Noble, Ross

Born in Newcastle, Ross Markham Noble was brought up in Cramlington. He studied performing arts at Newcastle College but always wanted to be a comedian. He eventually became one and has never looked back (as he has a stiff neck!). He is regularly seen on TV on panel shows and his stand-up arena shows are often sold out well in advance.

Northern Stage

The former University Theatre was opened in 1970 to replace the demolished Flora Robson Theatre in Jesmond, and it was here where Sting worked part-time as a support musician at Rock Musicals. It later became the Newcastle Playhouse before closing for a major refurbishment, costing £9 million, to reopen in 2006 as Northern Stage, a theatre and producing company. Sting returned in 2018 to launch the British tour of his musical *The Last Ship*, based on his home-town shipyard Swan Hunters in Wallsend.

Northumberland Street

The famous shopping street in Newcastle, which is now pedestrianised, at one time had all the main national department stores fronting onto the busy A1 trunk road passing through the centre of the city.

O

O2 Academy
The present popular music venue started life in 1927 as the Westgate Picture House. In 1959 it became the Majestic Ballroom and in the 1960s The Beatles and The Who appeared there. In the early 1980s it became the Gala Bingo Club until it was taken over as a music venue first called the Carling Academy until it got its present name in 2008.

Old George
Reputed to be the oldest pub in Newcastle and originally a coaching inn just off the busy medieval Bigg Market, the Old George represents a typical burgage plot being a narrow long building built between the frontage onto Bigg Market and the valley of the Lort Burn to the rear with the entrance off a narrow chare or lane. Charles I is reputed to have been a regular visitor when he was a prisoner in Newcastle in 1646–47 and the chair he sat on can still be seen there today.

Olusoga, David
The BBC history presenter of *Black and British* and *A House Through Time* spent his childhood in Newcastle. He describes himself as a 'Geordie Nigerian' whose family experienced a difficult time as he grew up on a council estate. He went to university in Liverpool where No. 62 Falkner Street, the house featured in the above programme, was filmed.

Onwurah Chi, MP for Newcastle Central
Chi Onwurah was born in Wallsend, grew up in Kenton and got a degree in electrical engineering in London. She worked in industry before she was elected as the first black MP in Newcastle for Labour serving Newcastle Central in 2010. At the time of writing she was the Shadow Minister for Industrial Strategy, Science and Innovation.

Ouseburn
The valley of the Ouseburn, a tributary of the River Tyne, was once a centre of industry with a wide range of manufacturers including the famous Maling pottery business. In recent years it has reinvented itself as a centre for arts and culture as well as supporting many local businesses and the well-loved Ouseburn Farm. Seven Stories, the National Centre for Children's Books, the Toffee Factory business centre, the Cluny music venue and the famous Victoria Tunnel entrance can all be found in Ouseburn.

Oxford Galleries

This once famous dance hall was built in 1925 on New Bridge Street adjoining John Dobson's 100-year-old house. The main ballroom area covered the site of John Dobson's original extensive gardens. Thousands of Newcastle couples will have met there before later getting married, and it continued as a dance venue until the 1980s before becoming a nightclub. Over the years it had many names including Tiffany's, Ikon, Liquid Envy etc., but it will always be remembered for featuring in Michael Cain's cult film *Get Carter* in 1971.

Oxford Galleries and John Dobson's House, New Bridge Street.

Parsons, Sir Charles

Most famous people who come from Newcastle have a statue erected in their memory, but Sir Charles Parsons, the inventor of the steam turbine, has the *Parson's Polygon*. This unique artwork in Blackett Street has another unusual feature in that it functions as an air vent to Monument Metro station below. It was erected in 1985 as a tribute to the famous inventor and the terracotta tiles covering the polygon incorporate designs taken from his working drawings. Parsons was born in London in 1854 and started work in Armstrong's factory in Newcastle. He moved to Clark Chapman Co. in Gateshead where he developed his steam turbine. He then set up his own company in Heaton to develop his turbines, following the success of the *Turbinia* at the 1897 Spit Head Review, where it was seen to be the fastest steam ship of its day. The famous Cunard liner *Mauretania*, which was the fastest vessel between Britain and America for over twenty years from 1907, was built at Wallsend using the newly developed turbine engine.

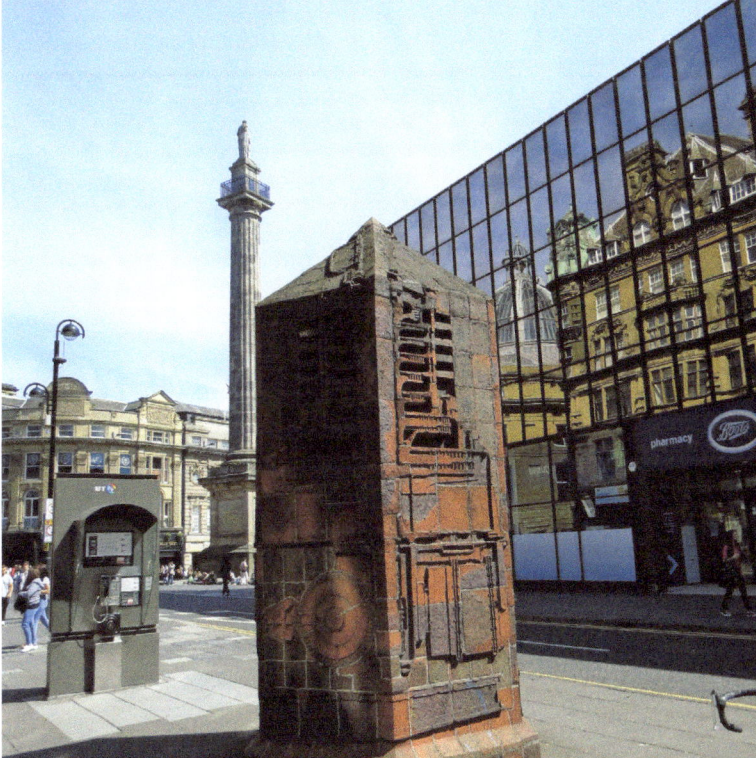

Parson's Polygon, Blackett Street.

A–Z of Newcastle

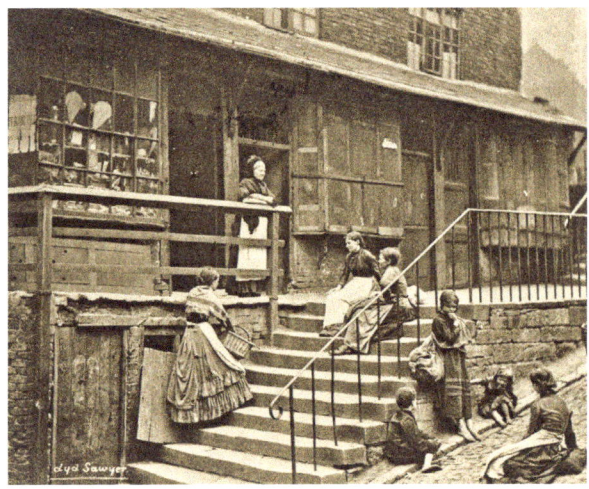

Pilgrim Street beside All Saints' Church, *c.* 1903.

Pilgrim Street and Gate

Pilgrims heading for St Mary's Chapel in Jesmond used to travel along this street after crossing the Tyne Bridge and climbing Butchers Bank. The street terminated at the town wall where Blackett Street is now and pilgrims passed through the Pilgrim Street Gate to continue their journey.

Pons Aelius

The Roman name for Newcastle was Pons Aelius, which translates as the 'bridge of Hadrian'. Pons is the Latin word for bridge and Aelius was the family name of Hadrian, the Roman emperor from AD 117–138. When he visited Britain in AD 122 he ordered a bridge to be built across the River Tyne, where the Swing Bridge now stands, while at the same time gave orders to build the Roman wall from Newcastle to Bowness to define the northern edge of the Roman Empire. The wall was extended to Wallsend in AD 126 and later around AD 200 a Roman fort also named Pons Aelius was built on the site of the present castle. The name is featured on the mural in Northumberland Road.

Pons Aelius on a mural in Northumberland Road.

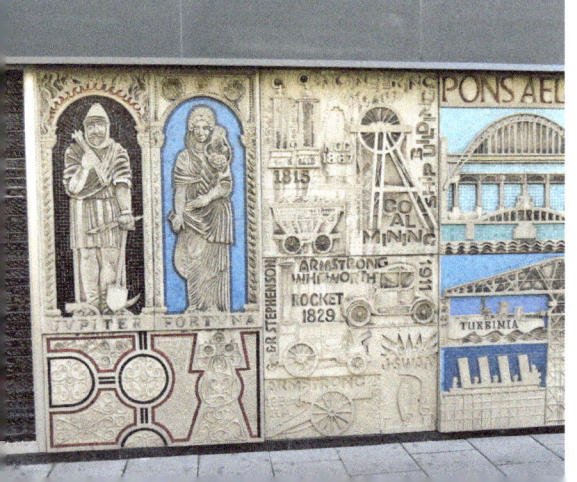
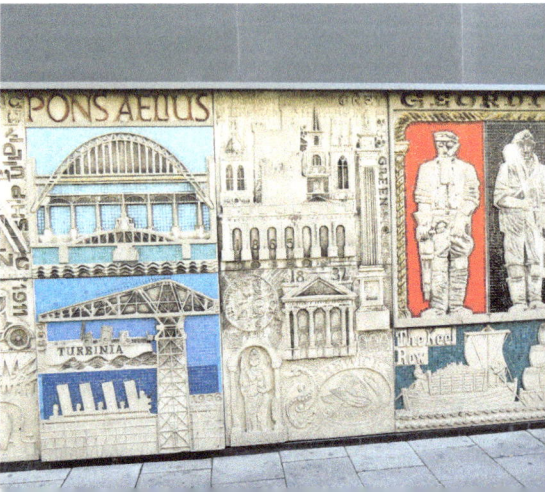

Port of Tyne

Newcastle Port, as it is sometimes referred to, is actually based to the west of North Shields close to the mouth of the River Tyne. The Port of Tyne is an international ferry port and cruise port of call with deep-water berths to accommodate some of the world's largest cruise ships. It runs a daily ferry service to Amsterdam as well as other seasonal services to other ports. In recent years it has become an important cruise ship destination as well as offering cruises starting from the Tyne to many parts of the world.

Purvis, Billy

Billy Purvis (1784–1853) was a famous nineteenth-century comic actor, musician and showman who lived in Newcastle and travelled all over the North to perform his act. He sometimes wore a distinct outfit that included a hooped costume and a cone-shaped hat (similar to a clown). He could do magic tricks and he played the union pipes to a high standard. He was referred to as the 'Jester of the North' and he died in Hartlepool during one of his tours; news of his death was mourned nationwide.

Billy Purvis.

Q

Quayside

The Quayside fronts the river and is famous for its Sunday market as well as being a popular entertainment area with many bars and restaurants. For centuries it was the centre of Newcastle Port where hundreds of ships from all over the world would discharge and load up their goods. Until the great fire of 1854 it was a densely built-up area with houses crammed together separated by narrow chares (alleys) and occupied by the poor. In the 1990s the whole area of East Quayside was redeveloped to form an attractive riverside walkway with numerous artworks including the *Blacksmith's Needle*. The area even had a TV soap opera made by Tyne Tees Television based in the area called *Quayside* that ran for one series in 1997. Today *Geordie Shore* features the area on a regular basis.

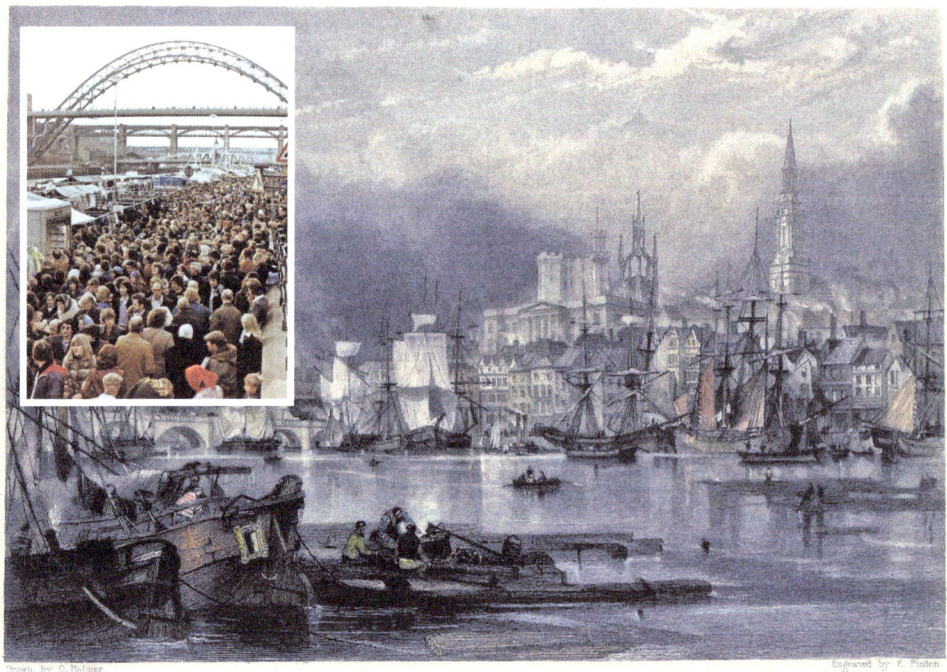

Quayside, *c.* 1836. *Inset*: Quayside Market in 1986.

Queen Elizabeth II Bridge

The bridge was opened by the Queen on 6 November 1981 together with the new cross-Tyne Metro track. It was first used by the public on 15 November travelling for the first time from the new Haymarket to Heworth Metro stations. It was designed by W. A. Fairhurst & Partners and built by the Cleveland Bridge and Engineering Co. and took four years to build.

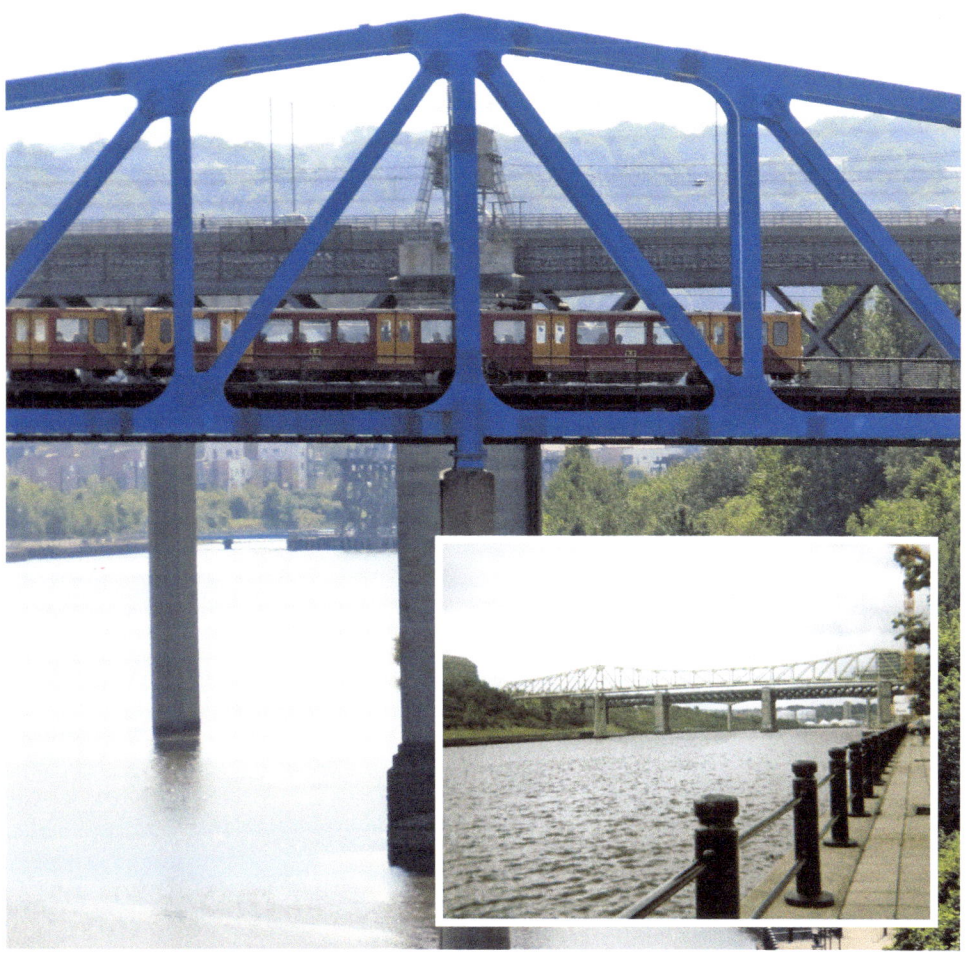

Queen Elizabeth II Bridge, King Edward VII Bridge and Redheugh Bridge.

Racecourse

Newcastle Racecourse at Gosforth Park has been the home of horse racing since it moved from the Town Moor close to Grandstand Road (named after the grandstand) in 1882. It has an all-weather track and stages national hunts and flat racing. It also hosts the 'Pitman's Derby', The Northumberland Plate, in June in 'Race Week' when the Hoppings funfair visits Newcastle on the Town Moor.

Ramsey, Chris

The star of the TV series *Hebburn* (2012–13) Chris Ramsey has also been seen on many TV comedy shows. He was born in South Shields and became a stand-up comedian and is a regular at the comedy clubs in Newcastle.

Redheugh Bridge

The present concrete Redheugh Bridge was designed by Mott, Hay and Anderson and was opened on 18 May 1993 by Princess Diana. It was the third Redheugh Bridge with the other two metal girder bridges dating from 1871 and 1900. The previous two bridges suffered from design faults but the present bridge also suffers problems during high winds and has to be closed at times to high-sided vehicles.

Renforth, James

One of the three famous Tyneside rowers to become a world champion rower in the nineteenth century, James Renforth from Newcastle held his title from 1868 to 1871 when he died, aged only twenty-nine, during a race in Canada. His body was brought back to England and he is buried in Gateshead where is a memorial to him outside the Shipley Art Gallery in the town.

Response

The impressive war memorial on Barras Bridge is called the Response and features soldiers marching behind a drummer boy on their way to fight in the First World War. It is thought to be one of the best war memorials in Britain. It was sculpted by Sir William J. Gascombe John and paid for by industrialist Sir George Renwick, whose five sons came back alive from serving in the conflict.

Response War Memorial, Barras Bridge.

Ridley, Geordie

The famous Geordie anthem the 'Blaydon Races' was written by Geordie Ridley (1835–64) in 1862 and was first performed at Balmbra's Music Hall that year to celebrate Harry Claspers' retirement. He was born in Gateshead and worked in the local colliery from seven years of age. He later worked riding on the wagons at the local ironworks and was badly injured during an accident. He then turned to being an entertainer and songwriter and had considerable success. We know he performed at the Mechanics' Institute at Blaydon as the self-publicist includes the fact in the 'Blaydon Races'. Sadly he was never in good health and died in 1864 aged just thirty.

River God

Situated on the Quayside beside the Millennium Bridge, the River God sculpture sits on a high column at the foot of the Sandgate Stairs that lead to another statue of the Siren.

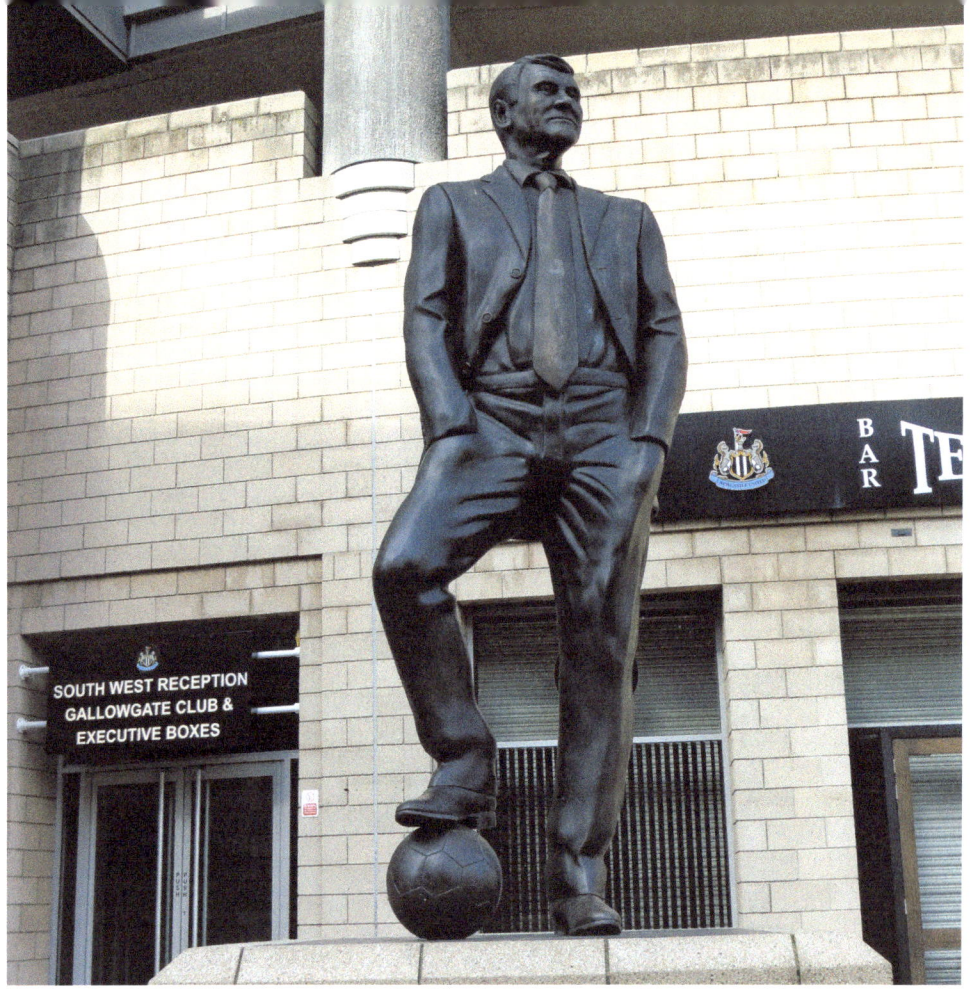

Bobby Robson statue, St James' Park.

Robson, Sir Bobby

Former England manager Sir Bobby Robson had his last managerial job at Newcastle United from 1999 to 2004. In that time he revived the team from a mid-table position to competing at the top of the Premier League and in Europe. More importantly he came home to manage his boyhood team and through his cancer charity has left a lasting legacy on the people of the North East who genuinely loved him. The Sir Bobby Robson Foundation set up in 2010 has generated millions for research and the treatment of cancer. A statue to Sir Bobby was erected outside St James' Park in 2012, a year after a memorial garden to him was opened on Gallowgate.

Rocket

The star attraction of the Exhibition of the North in 2018 is Stephenson's Newcastle-built locomotive *Rocket*, which is returning home from the Science Museum in London where it has been since 1862. It will have a short visit nearly 200 years after it was built (1829) in the Robert Stephenson & Co. Locomotive Works behind the Central station. Some of the original buildings still survive in South Street and there is a blue plaque to Robert Stephenson on the wall of the former office block.

Royal Victoria Infirmary, Queen Victoria Road.

Royal Victoria Infirmary

In 1906 Edward VII opened the Royal Victoria Hospital on part of the town moor and unveiled a statue of his mother Queen Victoria. Since that time the hospital has evolved and part of it was redeveloped to form the modern hospital we know today. The hospital was built to replace the earlier infirmary established in 1752 that was situated beside the Central station.

Rutherford, Dr John Hunter

John Hunter Rutherford (1820–70) was a great advocate for the temperance movement. Ironically his memorial fountain with a sign on it stating 'Water is Best' is situated in the middle of the Bigg Market, a centre for nightlife in Newcastle. He was born in Jedburgh and came to Newcastle as a medical doctor in 1850 aged twenty-four. He was an evangelist at Bath Lane Congregational Church and set up a Sunday school and gave out free breakfasts to poor children as part of his mission to improve the lives of the poor. He worked closely with Joseph Cowen MP to develop education for all classes of society and the Rutherford Memorial College was established on Bath Lane after his death. This college evolved to become part of Newcastle Polytechnic, later the Northumbria University, and Rutherford is acknowledged as one of its founders.

S

St Andrew's Church, Newgate Street.

St Andrew's Church

This twelfth-century church is reputed to be the oldest original church in Newcastle, having more medieval features preserved than the other three parish churches. Its name reflects links with Scotland and may have been built by King Malcolm of Scotland when the town was under Scottish control from 1139 to 1157. Some people have speculated that Newcastle could have become the capital of Scotland during this period. Fifteen witches were buried in the graveyard in 1650 after being condemned by a witch finder.

St James' Park Stadium

Newcastle United have been based at St James' Park since 1892, although the ground has changed considerably over the years. It is one of a few cities in England to have a major football club that holds over 52,000 fans, known as the 'Toon Army', in the town centre. It is often referred to as Newcastle's third cathedral and the players are often referred to as saints or sinners!

S

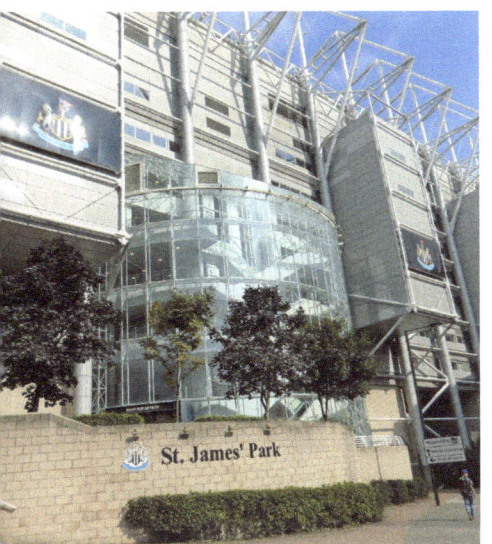

St James' Park, 2017 and *c.* 1978.

St John the Baptist Church

The present church dates from around the fifteenth century but probably replaced an earlier church dating from the twelfth century. It was built originally as a chapel for St Nicholas' Church but later went on to serve one of the four parishes within the town as the population increased in medieval times. Robert Rhodes, who died in 1474, was a main benefactor and his coat of arms, a dog above three circles (often referred to as a whippet and three stotties), can be seen on the south side of the church above a projecting gable window.

St John's Church, Westgate Road and Grainger Street.

St Mary's Cathedral, Clayton Street.

St Mary's Cathedral

The Roman Catholic cathedral was built in 1844 and designed by the famous architect A. W. N. Pugin, who designed the Houses of Parliament in London. It became a cathedral in 1850. The garden and statue to the rear commemorates Cardinal Basil Hume, who came from Newcastle and became head of the Catholic Church in England.

St Mary's Church, Gateshead

Overlooking the Tyne Bridge, St Mary's Church has occupied this site since the twelfth century and was the main parish church for Gateshead until the last century. It was badly damaged in the Great Fire of Gateshead and Newcastle in 1854. Today it is an important tourist attraction and community meeting place.

St Nicholas' Cathedral

St Nicholas' Church became St Nicholas' Cathedral in 1882 when Newcastle became a city (although many locals still call it the 'Toon'). It was one of the four medieval parish churches and was always the largest. The impressive and rare lantern tower was built in the fourteenth century and originally housed a coal-fired beacon to guide ships up the River Tyne. It is open daily for visitors to see the outstanding wood carving of Ralph Hedley, the memorial to Admiral Lord Collingwood, the medieval font and to visit the welcoming café.

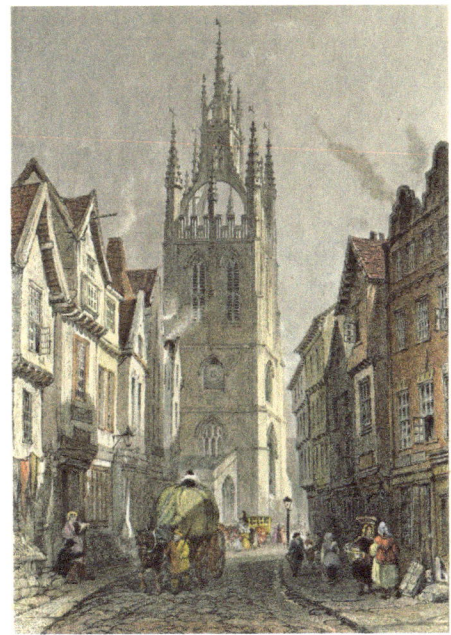

St Nicholas' Cathedral, St Nicholas' Street, 2014 and *c.* 1800.

St Oswald's Hospice

Funded entirely by charity, St Oswald's Hospice in Gosforth was established in 1986 and has provided caring services to thousands of locals with life-limiting conditions over the years. The charity has a number of shops in the area and has used many unusual ways of raising money including midnight walks and organising a 'Snowdog' trail around the region.

St Thomas the Martyr Church

This was one of the first churches to be designed by Newcastle's famous architect John Dobson and was opened in 1830. It is also one of the few prominent buildings in the town centre not to be stone cleaned in the 1960s and 1970s and retains its sooty appearance. It was built to replace the original St Thomas à Beckett Chapel that was situated at the north end of the medieval Tyne Bridge that was demolished in 1827 to improve traffic movements. It does not have a parish and the leader is called the master rather than a vicar.

St Thomas's Church with statue of St George, Barras Bridge.

Sage

This landmark curved glass and stainless steel building, designed by Fosters & Partners Architects, dominates the Gateshead riverside and was opened in 2004 as the Sage concert venue. It is occupied by the North Music Trust and is home to the Royal Northern Sinfonia as well being an education resource, a concert and conference venue. Many famous orchestras and stars have played here including Sting and both the Labour and the Liberal Democrat parties have held conferences here. It is open to the public daily and has a café open to all.

Sandgate

Sandgate was one of the gates through the town wall that led on to the Sandgate area of the town where many keelmen lived and where they built the Keelmen's Hospital in 1701.

Sandhill

A mound of sand at the mouth of the Lort Burn beside the medieval Tyne Bridge became known as Sandhill and this is where the Guildhall was built and early markets were held.

Science Central (Helix)

Situated on the edge of the city centre to the west of St James' Park is the developing new centre for science known as Science Central or Helix. The site of the former Newcastle Brewery is being transformed with state-of-the-art buildings being developed in a partnership with Newcastle University, Newcastle City Council and private investors. It is hoped that over 4,000 new jobs will be created on the site as well as 450 new homes, all using the latest green energy to be supplied by a new energy centre.

Scott, Sir Ridley

Award-winning director of *Aliens* and *Blade Runner* Sir Ridley Scott was born in 1937 in South Shields. He was no doubt inspired by the Roman heritage of the town and its own Roman fort of Arbeia when he agreed to direct *Gladiator* in 2000.

Seven Stories

In 2005 the National Centre for Children's Books, known as Seven Stories, was established in a former seven-story granary warehouse in the Ouseburn area of Newcastle. It is a museum and visitor centre dedicated to children's literature and holds some important archives of famous authors including Enid Blyton, Michael Morpurgo and Robert Westall, from North Shields and author of *The Machine Gunners*. The museum regularly changes its exhibitions and also runs workshops hosted by famous children's book authors, including in the past David Almond, Terry Deary and Julia Donaldson.

Segedunum

Segedunum Roman Fort at Wallsend is the largest Roman museum on Tyneside and is only 4 miles from Newcastle. It is situated a short walk from Wallsend Metro station, which is famous for having the only dual-language information signs on the transport system featuring Latin as well as English signage. Wallsend, as the name suggests, is where Hadrian's Wall terminated at the River Tyne. The Roman fort called Segedunum was built to protect the wall in AD 126. As you would expect a life-sized replica of Hadrian's Wall has been built on site and is available for visitors to ascend and walk on the 5-metre-high walkway, but the throwing of spears at present-day residents living north of the wall is not permitted. Sting, who was born and lived in Wallsend, spent some of his childhood living in a dwelling built above the Roman fort itself before moving to nearby Station Road. The museum has a 30-metre- (100-feet-) high viewing tower overlooking the site from which the former Swan Hunter shipyard, famous for building such ships as *Mauretania*, *Illustrious* and *Ark Royal* can be seen. The TV series *Vera* uses the Swan Hunter offices as the police station in the programme.

Shearer, Alan

Alan Shearer is Newcastle United's record goalscorer with 205 goals in 395 appearances for his home town club where he played for more than a decade. He became the most expensive footballer in the world following his £15 million transfer from Blackburn Rovers in 1996. The former England captain managed the team briefly in 2009 as he tried to avoid relegation from the Premier League. He had a statue to him erected outside St James' Park in 2016 and is now a TV football pundit. Following his testimonial in 2006 he set up the Alan Shearer Centre in West Denton, which provides family respite care facilities as well as raising over £1 million to help sick children and other charities. (*See* page 10 for mural.)

Alan Shearer statue, St James' Park.

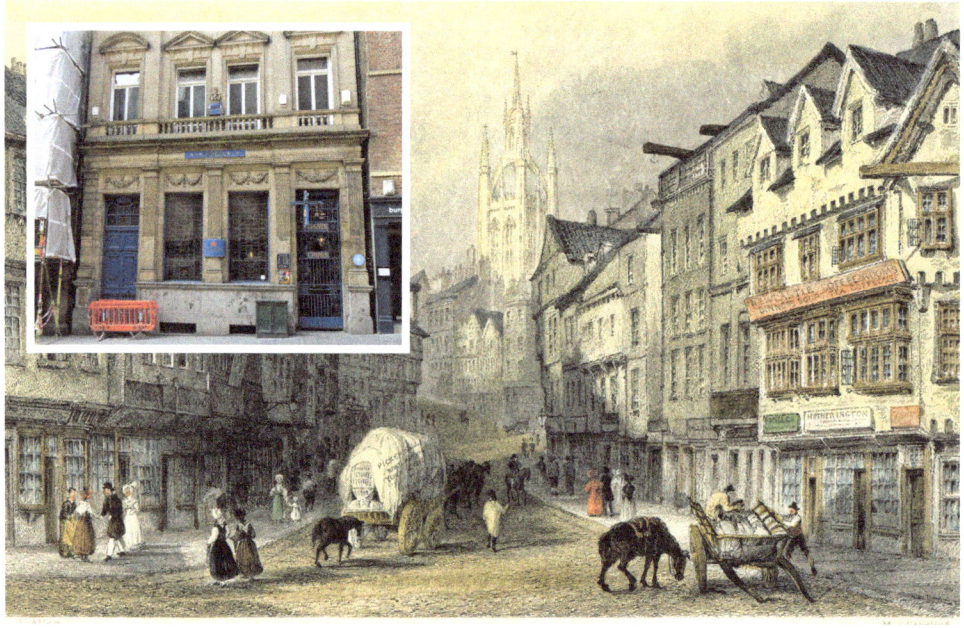

Side, c. 1833, and Crown Posada, 2012.

Side

The narrow street leading from the Quayside below the Black Gate is known as Side and was once part of the A1 or Great North Road. Cuthbert Collingwood was born in a house on Side in 1848. The Crown Posada pub is also on the street.

Shukla, Hari

Dr Hari Shukla arrived in Newcastle in 1974 to become director of Tyne & Wear Racial Equality and he described the situation then as being terrible. Since then he has worked tirelessly to improve the situation and has been awarded an MBE, OBE and CBE in recognition of all his good work over the years for improving race relations.

Skipsey, Joseph

The famous 'Pitman Poet' Joseph Skipsey (1840–1920) from Percy Main worked in the collieries for many years as he developed his writing skills. He eventually was offered a job in the library at the Lit & Phil but did not stop long and left to return to the mines and continue writing poetry. Later in life he was appointed custodian at Shakespeare's Birthplace in Stratford upon Avon, but only stopped for two years and came back home disenchanted and retired. His most notable work was 'The Hartley Calamity' recording the events of the 1862 Hartley Pit Disaster where 204 men and boys were killed. He also experienced tragedy in his own life as his striking miner father was shot dead when he was only aged eight. During his lifetime he also lost five of his eight children with three dying within one month due to an infection.

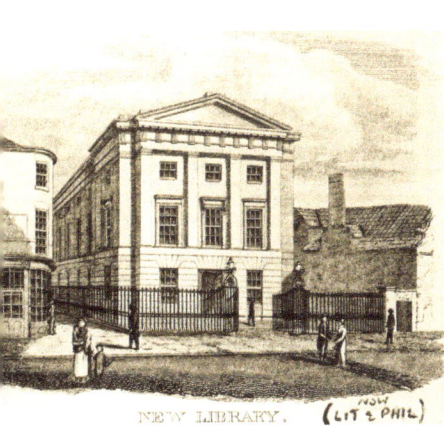

Joseph Skipsey and Literary and Philosophical Society, c. 1850.

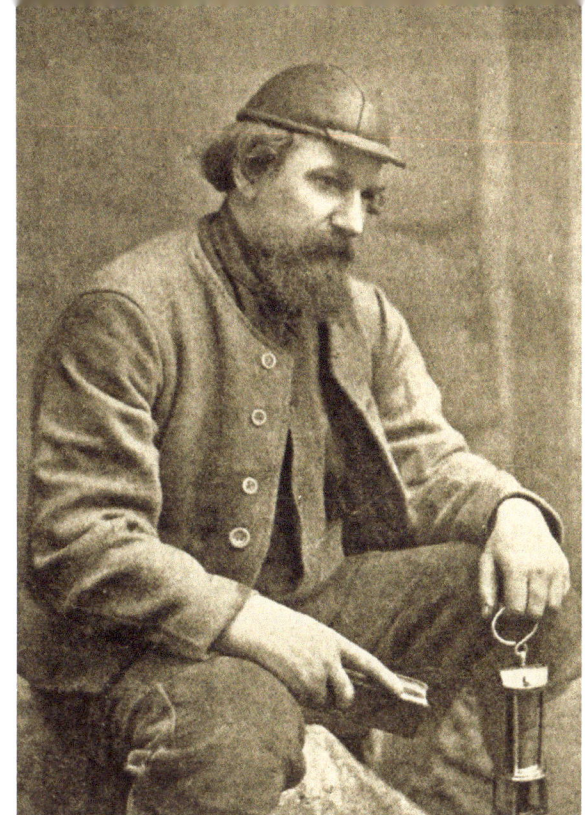

Smith, T. Dan

Thomas Daniel Smith (1915–93) was born in Wallsend and was known as T. Dan Smith. He was also known as 'Mr Newcastle' for many years when he was leader of Newcastle Council in the 1960s and a very prominent politician on both the local and national stage. He was a great believer in town planning and employed Wilfred Burns as the first city planning officer in the first Planning Department in the country. He is said to have wanted to create a 'Brasilia of the North' in the city. During his time in office he promoted slum clearance, city centre redevelopment, the development of the university and the preservation of such historic buildings as Blackfriars, Holy Jesus Hospital and the Keelman's Hospital. He is, however, remembered for being jailed for corruption, with developer John Poulson, as well as building unpopular blocks of flats, brutal concrete buildings and for the loss of the Royal Arcade to build the Swan House roundabout over the new motorway. The 1996 television series *Our Friends in the North* featuring a young Daniel Craig was loosely based on T. Dan Smith's life on Tyneside.

Spedding, Charlie

The Olympic bronze medallist for the marathon in Los Angeles in 1984 and winner of the London Marathon in 1984, Charlie Spedding was a Gateshead Harrier and competed for many years in local races. He was also a pharmacist by trade.

Spender

Jimmy Nail co-wrote *Spender* and had the starring role in this gritty TV cop drama that also starred Sammy Johnson as Stick, as well as Denise Welch and Brendan Healy. The programme was aired for three series from 1991 to 1993.

Stadium

Newcastle Stadium, formerly known as Brough Park, in Walker has been the home of greyhound racing since 1928 and Newcastle Diamonds speedway team since 1929.

Stephenson, George

George Stephenson is often referred to as the founder or the father of the railways. He was born in Wylam in 1781 and started life with no education working in the mines. He taught himself how to read and write as he demonstrated his ability to learn on the job, working in various roles on different machines. When he became an engine-wright at Killingworth Colliery he invented a safety lamp that was named the Geordie Lamp after him. He then began to experiment with fixed and moving engines. By 1814 he had built his first steam locomotive. In 1822 he was appointed engineer to the Stockton & Darlington Railway, the first passenger railway in the world, which opened in 1825 with him driving the *Locomotion* pulling twenty-one cars of people and eleven loaded wagons up to an amazing speed of 12 miles an hour. With his son Robert he set up the world's first locomotive factory behind the Central station where the famous *Rocket* was built in 1829. His statue sculpted by J. G. Lough in Neville Street was unveiled in 1862.

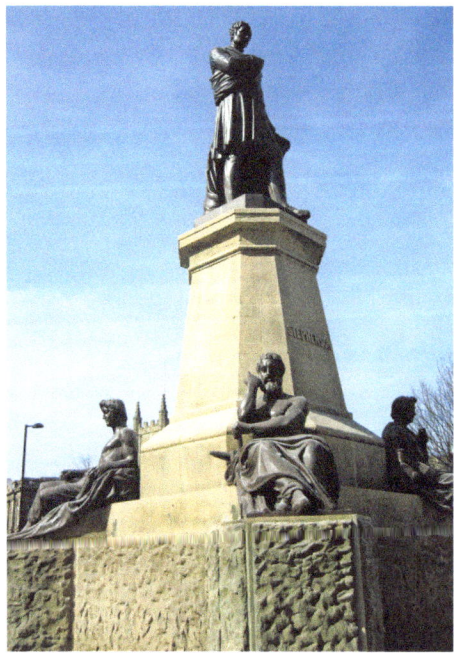

George Stephenson Memorial, Westgate Road, and Robert Stephenson.

Stephenson, Robert

Son of George and born in Willington Quay in 1803, Robert was educated at Bruce's School in Newcastle and was apprenticed to the eminent mining engineer Nicholas Wood surveying the Stockton & Darlington Railway. He then joined with his father in setting up a locomotive factory named Robert Stephenson's Engine Works in 1823 when he was twenty one. He worked in South America for three years before returning to help develop *Rocket* and survey the London & Birmingham Railway. He then designed the now famous railway bridges at Newcastle, the High Level Bridge (1849), the Royal Border Bridge (1850) at Berwick and the Britannia Tubular Bridge (1850) across the Menai Straits in Wales. He received many honours and following his death in 1859 he was buried in Westminster Abbey.

Sting

Gordon Mathew Sumner was born in Wallsend in 1951 and later went to school in Newcastle. He trained as a teacher while he played in local bands (where he got his name after wearing a yellow-and-black-hooped jumper) before moving to London looking for a big break. He got this by teaming up with Andy Summers and Stewart Copeland to form The Police. They soon broke into the charts then went on to conquer both Britain and America before going global and selling millions of records. Sting also had an acting career at the same time and starred in a number of films including *Dune* and *Stormy Monday* (which was set in Newcastle). After The Police broke up in 1990 he had a successful solo career. In 2013 he wrote the musical *The Last Ship* based upon shipbuilding in Wallsend. It was performed on Broadway and later in the run he replaced Jimmy Nail as the main character before it closed down. He brought the production back to his home area in March 2018 to be performed at the Northern Stage Theatre. This was a venue he had one performed at himself when it was the University Theatre when he was a student playing in a support band. (*See* page 54 for mural.)

Swan, Sir Joseph Wilson

Born in Sunderland in 1828, Joseph Swan moved to Newcastle to work for the chemist John Mawson and later they set up the long-established shop Mawson Swan & Morgan that many locals will remember in Grey Street. Joseph Swan is world famous for inventing the incandescent light bulb, which he demonstrated in 1879 at the Lit & Phil. He later entered a partnership with the American inventor Thomas Edison and the company was called Edison & Swan and sold light bulbs to the world from their Gateshead factory. Swan also invented many products associated with improvements to photography. He lived for many years in a large house in Low Fell, was later knighted and Sir Thomas Wilson Swan died in 1914. There is a plaque to him on Carliol House in Pilgrim Street.

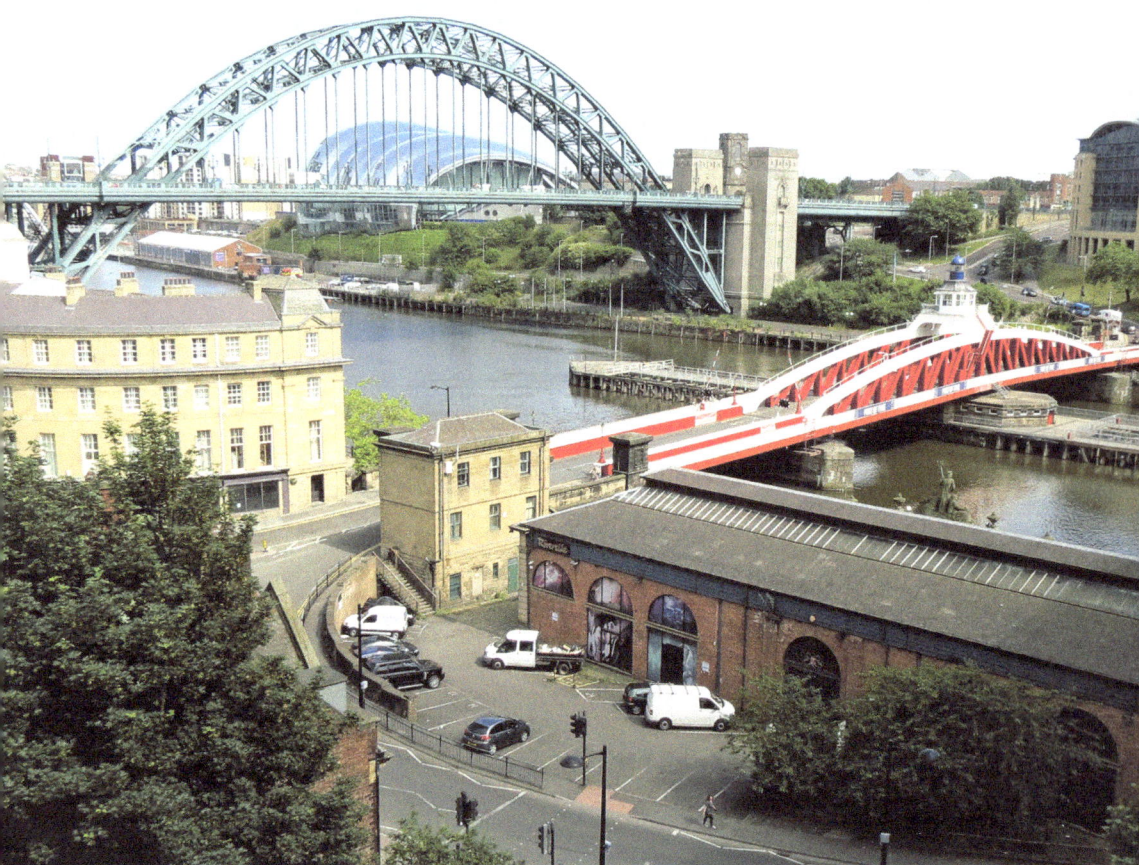

Tyne Bridge and Swing Bridge.

Swing Bridge

In 1876 without a formal ceremony the Swing Bridge was opened. It was designed by William Armstrong and it was one of the first hydraulically powered bridges of its type and the largest turning bridge in the world. It replaced the earlier Georgian bridge that was very restrictive to vessels due to its many low arches. The new bridge allowed large vessels to travel upstream, which led to the development of shipbuilding and coal exporting to the west of Newcastle and such developments as Armstrong's armament factory and shipyards as well as Dunston Staiths. This also had a devastating effect on keelmen on the Tyne, who depended upon transporting coal under the old bridge from the west.

Swirle Pavilion

The large pavilion-shaped artwork on the Quayside with a golden globe on top commemorates the many ports that traded with Newcastle over time as well as a hidden tributary – 'The Swirle' – that flows underneath on its way to the river.

T

Ternan, Nellie

Ellen 'Nellie' Ternan, the mistress of Charles Dickens, was the daughter of Thomas Ternan, the manager of the Theatre Royal, and his wife Frances, who was a successful actress. Thomas died when Nellie was seven and her mother introduced Nellie and her sister Fanny to acting at an early age, which is how they met Charles Dickens through his children who were also keen on acting. Nellie was featured in the recent film (2013) about Charles Dickens called *The Invisible Woman*, which referred directly to her, as she had been air brushed from history to protect the writer's reputation after he left his wife. Charles Dickens visited Newcastle to give talks on his books on a number of occasions at the former Music Hall in Nelson Street.

Theatre Royal

The Theatre Royal is the second theatre with this name and it opened in 1837 after the earlier one, built in 1788, had been demolished to make way for Grey Street. It was designed by John and Benjamin Green for Richard Grainger as a landmark building in his town centre redevelopment scheme. Today it is still Newcastle's premier theatre but it has seen some changes over time. It was badly fire damaged in 1899 and was

Theatre Royal, Grey Street, *c.* 1870 and 2014.

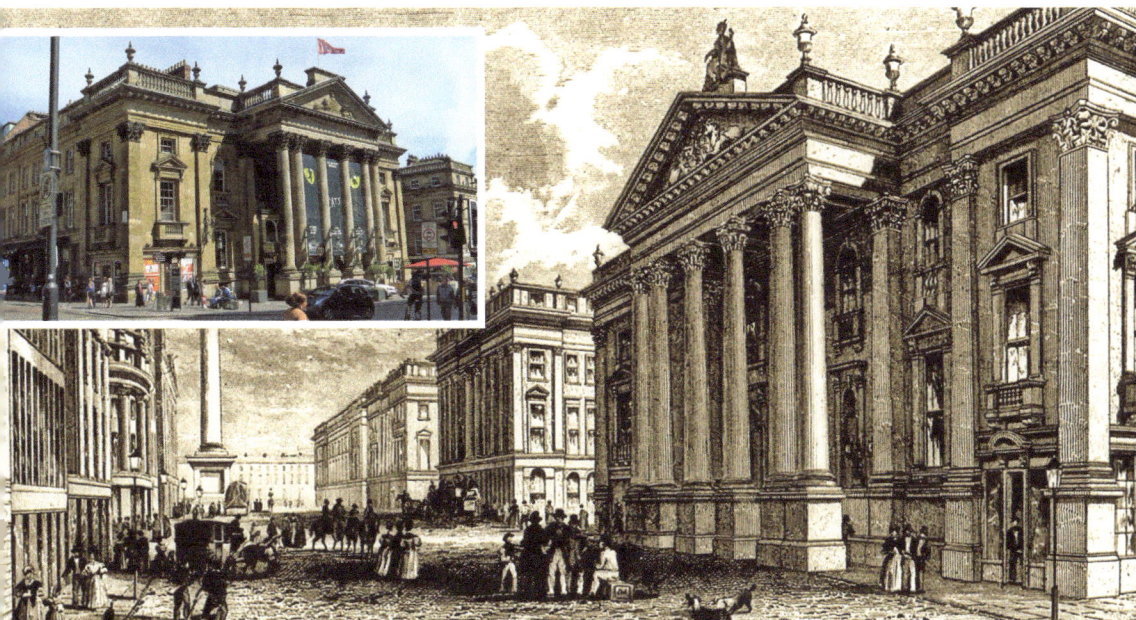

restored by the famous theatre designer Frank Matcham. It underwent another major refurbishment in recent years and reopened in 2011 after a £5 million facelift. For many years the Royal Shakespeare Company regarded the theatre as its second home.

Thompson Bobby

The 'Little Waster' was Bobby Thompson's nickname and he appeared in clubs and theatres all over the North East from the 1930s to the 1980s. His broad Geordie or pitmatic accent used in his act meant that his television career did not develop to reflect his popularity in the clubs. He was born in Penshaw, the youngest of seven children. Both of his parents died before he was eight and he was brought up by an aunt. At fifteen he worked at the local colliery and supplemented his wages by developing his music and comedy act in local clubs. He always had problems with the taxman – mainly because he didn't like to pay any tax! He was married three times and lived out his later years in Monkseaton.

Thompson, Tanni Grey

Baroness Tanni Grey Thompson was made chancellor of the Northumbria University in 2015 following a distinguished career in Paralympic sport as a wheelchair racer. She represented Great Britain for years at major championships and won nineteen medals (eleven gold) and set thirty world records on track and road. She also won the London Marathon six times and the Great North Run eight times. She is now seen as a champion for diversity, youth and wellbeing and lives with her family in Durham.

Thornton, Roger

There is a statue to Roger Thornton on Northumberland Street above a former Boots shop alongside others for Thomas Bewick, Sir John Marley and Harry Hotspur. Few people have heard of the Dick Whittington of Newcastle who is said to have arrived penniless but ended up as the richest merchant in town in the fifteenth century. He became mayor and was a great benefactor giving money to churches and setting up a home for the poor. Thornton Street is named after him and he has an impressive brass memorial to him and his family in St Nicholas' Cathedral.

Thunder Rugby League Club

Based at Kingston Park, the home of Newcastle Falcons Rugby Club, Newcastle Thunder Rugby League Club moved from Gateshead where they were known as Gateshead Thunder in 2015. They compete in the Kingstone Press League 1, which is the third tier of Rugby League.

Town Walls

Newcastle's town walls extended for over 2 miles when they were built in the late eleventh and early twelfth centuries to overcome the threat of the Scots. They also had seven main gates, nineteen towers and thirty turrets, as well as seventeen water gates on the Quayside. The majority survived until the early 1830s when large sections were removed to allow the town to expand and the gates were removed to improve

Corner turret, town walls, City Road, Pandon.

traffic movements into the town. Large sections of wall still remain near China Town, behind the Central station and at Pandon, as well as a number of towers and turrets.

Town Moor

To the north of the central area of Newcastle is the Town Moor, an area of open space or common land granted to the people of Newcastle by King John in 1213. At 400 hectares (1,000 acres) it is larger than Central Park in New York and is controlled by dual owners the Freemen of Newcastle (who have grazing rights on the land) in association with the city council. It is the home of a major outdoor fair, known as the Hoppings, said to be the largest travelling fair in Europe, which is held in June each year. Over the years there have been many encroachments onto the original moor but land has been set aside elsewhere in the city to compensate for the loss.

Trinity House

Trinity House has a collection of some of the oldest buildings in Newcastle. Established in 1536 by Henry VIII as the 'Guild of the Blessed Trinity', it was set up to improve navigation on the River Tyne. Initially they removed sandbanks and deepened the river and then built lighthouses at the mouth of the Tyne, all paid for by taxing ships using the river. It also oversaw all river pilots using the river. Today it still provides a professional maritime consultancy service including licensing of deep-sea pilots. Trinity House also provides educational services as well as charitable support to past mariners and their families.

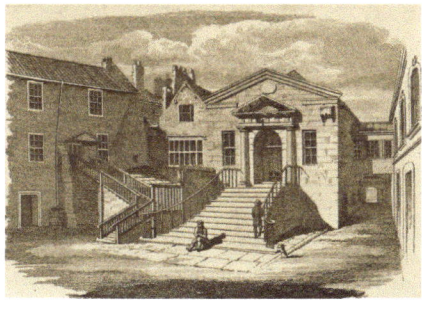

Trinity House, Broad Chare, c. 1800 and 2014.

Tuxedo Princess

In 1983 'The Boat' or Tuxedo Princess arrived on the Gateshead Quay as a floating nightclub. The former SS *Caledonian Princess*, a 1961-built Irish Sea car ferry, was bought by local businessman Michael Quadrini. The Tuxedo Princess and later the Tuxedo Royale were prominent features on the riverside under the Tyne Bridge and a popular venue until December 2007. In 2008, after twenty five years, 'The Boat' sailed off into the sunset and the breakers' yard.

Tyne Bridge

Opened in 1928 by George V, the famous Tyne Bridge has become the symbol of Tyneside and Newcastle in particular. It has featured on many adverts and in much publicity material for the area, not least the Great North Run when 50,000 runners cross over as the Red Arrows aerobatic team pass overhead. It was designed and built by Dormon Long of Middlesbrough, who also built the much larger Sydney Harbour Bridge.

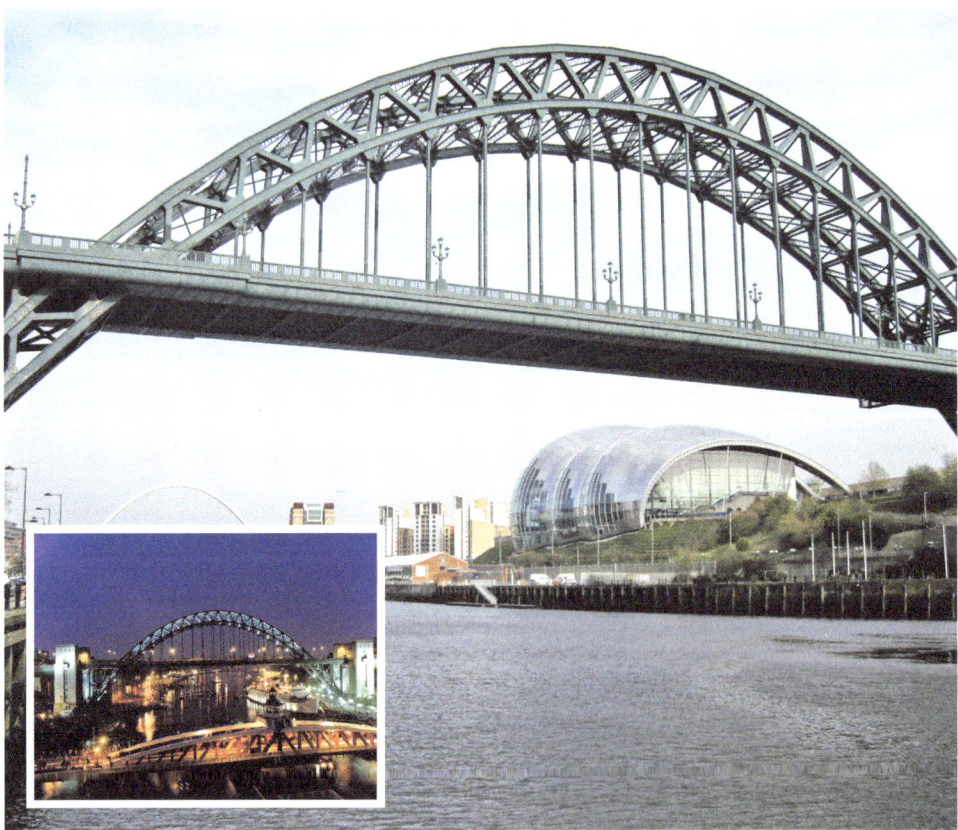

The Sage and Tyne Bridge. *Inset*: Tuxedo Princess, Tyne Bridge and Swing Bridge.

Tyne God

This striking sculpture on the wall of the Civic Centre used to have water pouring down from its hand and into the tray below. A good idea in theory but if you visited the building on a windy day you got a free shower. (*See* picture on page 21)

Tyne Theatre and Opera House

Joseph Cowen opened the Tyne Theatre and Opera House in 1867 as an alternative theatre for the working man. It operated as a theatre until 1919 when it became the Stoll Picture House until 1974. It later became a theatre again, opening in 1977. After a major fire in 1985 it was restored again and reopened in 1986. There is an interesting artwork installed opposite the theatre called *Ever Changing*.

Tyne Theatre and Opera House and *Ever Changing* artwork, Westgate Road.

Union Rooms

The Union Rooms on Westgate Road were built as a gentlemen's club, known as the Union Club, in 1877 in the French chateau style. The impressive building was converted into a public house in 1999. Until 2007 it was totally dominated by a thirteen-storey 1970s office block carbuncle known as Westgate House, which was built out over the street. This was demolished after being voted the biggest eyesore in Newcastle and new student accommodation has been built on the site.

Union Rooms, Westgate Road.

Universities

Newcastle University started life as part of Durham University and became a university in its own right in 1963. It was referred to as King's College Newcastle from 1937 when the two earlier schools merged. The first to be established was the School of Medicine and Surgery in 1834, followed by Armstrong College in 1871. The university has continued to grow and now has numerous departments with research facilities offering degrees in a wide range of subjects to over 20,000 students from over 100 countries. It is referred to as a red-brick university and is ranked in the top-thirty universities in Britain. The main campus is situated north of the city centre close to the Royal Victoria Infirmary.

The University of Northumbria at Newcastle was formerly known as Newcastle Polytechnic before 1992 and was ranked sixty-sixth in Britain in 2018. The main campus is based to the east of the city centre close to the central motorway and has a large teaching and sports area at Coach Lane in east Newcastle. In 2018 it had over 27,000 students, many of which were international, living in the numerous purpose-built student flats throughout the city centre.

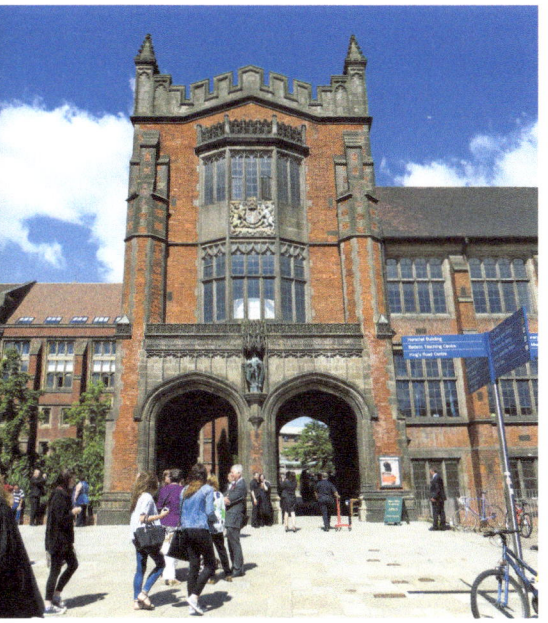
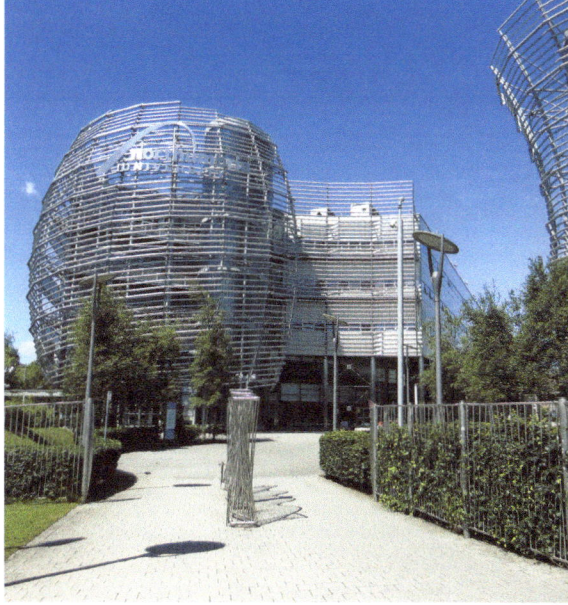

Above left: Newcastle University.

Above right: University of Northumbria.

V

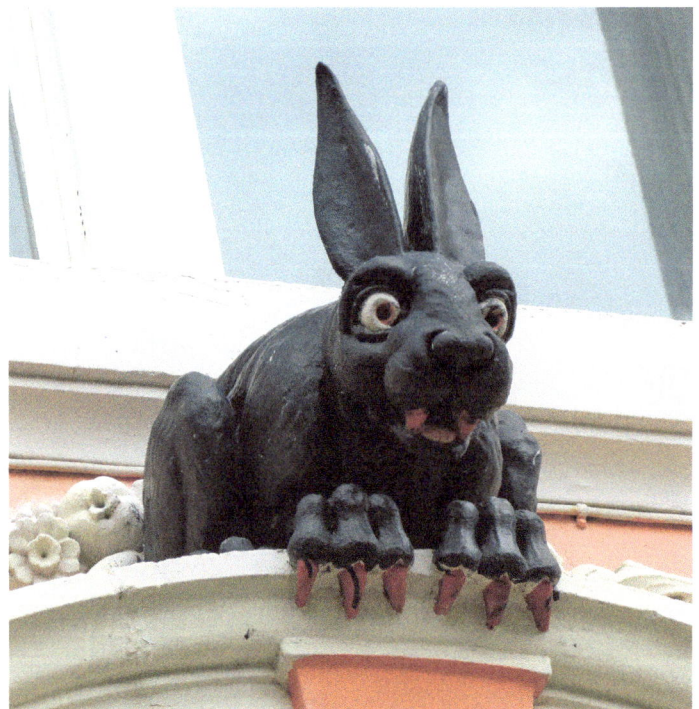

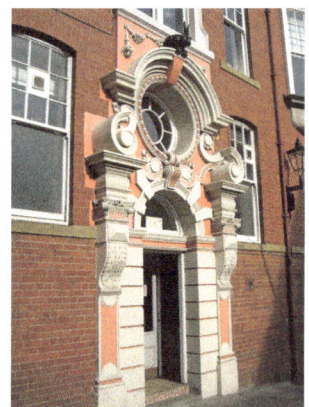

Vampire rabbit, Cathedral Buildings.

Vampire Rabbit

To the rear of St Nicholas' Cathedral over an ornate doorway in Cathedral Buildings is Newcastle's famous 'Vampire Rabbit'. The red-fanged creature stares down into the street like a medieval gargoyle but nobody knows why it is there or whether it was put there for a reason or even why it is called a rabbit as it looks more like a hare.

Vejjajiva, Abhisit

The former prime minister of Thailand was born in Wallsend while his parents were medical professors in Newcastle. Abhisit Vejjajiva was educated at Eton and then Oxford before becoming involved in politics in Thailand. Between 2008 and 2011 he was the 27th Prime Minister of Thailand.

V

Vera

The successful TV series *Vera* is filmed in and around Newcastle and Northumberland and is based on the books by Anne Cleeves, who lives in the North East. The police station used in most of the programmes used to be the offices of Swan Hunter shipyards in Wallsend. Newcastle's riverside has been featured many times, as well as many local buildings and streets.

Vermont Hotel

This hotel was originally built as the headquarters of Northumberland County Council in 1934, replacing a smaller building erected in 1910. It remained in use until 1974 when a new headquarters was built at Morpeth. It fell within an island of Northumberland County, which was historically centred in the original royal castle and was surrounded by the separate city and county of Newcastle upon Tyne. The building was converted to a hotel in 1993 and is unusual as it was built into the hillside with ten storeys on the east side and six facing the Moot Hall.

Victoria Statues

Both a young and old Queen Victoria can be found in Newcastle. In the grounds of the Royal Victoria Infirmary a bright white statue by Peter Frampton of the young queen can be found outside the former main entrance close to Peacock Hall. It dates from 1906 and was unveiled by her son Edward VII when the hospital was formerly opened. The black bronze statue by Albert Gilbert of the old queen can be found on the north side of St Nicholas' Cathedral. Here she is sitting on a throne looking less than amused as she did in her later years. It was erected in 1903 following her death in 1901.

Queen Victoria at Royal Victoria Infirmary and St Nicholas' Cathedral.

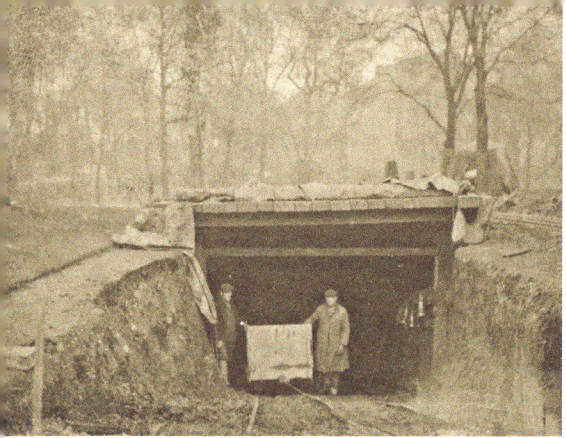

Victoria Tunnel air-raid shelter at Barras Bridge.

Victoria Tunnel

One of Newcastle's hidden gems is a former coal mine tunnel that runs beneath the streets of the city centre. It carried coal from Spital Tongues Colliery to the river at Ouseburn. It was only used for a few decades from 1835 to 1860 and was next used as an air-raid shelter during the Second World War. Now it is a major tourist attraction with a dedicated group of volunteers offering regular guided tours under the city from the entrance at Ouseburn. Visit www.ouseburntrust.org.uk.

Viz

Chris Donald, with the help of his brother Simon and others, created *Viz* comics in their bedroom in Jesmond in 1979. At first it was circulated around to students in pubs and soon it developed into a national magazine. It peaked in circulation at 1.2 million in 1989 but still had a circulation of over 50,000 in 2014. Some of the characters have been made into a cartoon series on Channel 4 including *Billy the Fish*, voiced by Harry Enfield, and *Sid the Sexist*, voiced by the late Sammy Johnson.

Victory, South Africa Memorial

The Angel at the top of the Boer War or South Africa War Memorial represents 'Victory'. The statue literally had to have its wings clipped in the 1980s when the Haymarket Metro station was built below it. The metal wings were replaced by fibre glass to reduce the weight of the memorial. The memorial was erected in 1907 in memory of the local men, many from the famous 'Fighting Fifth' regiment of the Northumberland Fusiliers, who fought and died in the 1899–1902 Boer War.

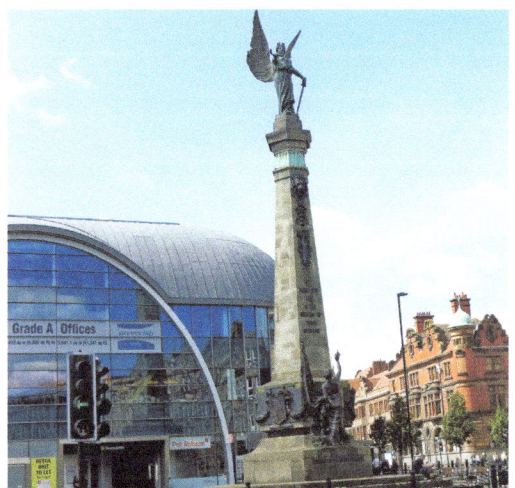

Victory on top of the Boer War memorial, Haymarket.

W

Waddle, Chris

Chris Waddle started his professional career with Newcastle United playing with Peter Beardsley and Kevin Keegan. He moved to Spurs and later Marseille and played for England in the World Cup. He is now a football pundit.

Waugh, Ed

Local playwright Ed Waugh, a great supporter of the Live Theatre and other small venues, has in recent years brought back to life some of Tyneside's forgotten heroes including Ned Corvan, Joe Wilson and Harry Clasper through his plays.

Welch, Denise

A local lass from Tynemouth with links to the sweet makers Welch, she married Tim Healy and also starred as Natalie Barns in *Coronation Street*. She was Jimmy Nail's wife in *Spender* and regularly performs in Newcastle for charity in Sunday for Sammy.

Wesley John

John Wesley, often referred to as the founder of Methodism, along with his brother Charles visited Newcastle on many occasions and has a square named after him opposite the law courts on the Quayside. There is also a fountain dedicated to him in the square, which originally stood on milk market where he first preached to the poor of Sandgate in 1742.

John Wesley Memorial, Wesley Square.

After initially being critical of the foul-mouthed children he encountered, he later said he could think of no better place to live than in Newcastle. John and Charles Wesley built an Orphan House on Northumberland Street, which was believed to be the second oldest Methodist chapel in England. It was replaced by the Brunswick Methodist Chapel in 1820 as the mother church in the North East.

Westall, Robert

The local North Shields-born children's author Robert Westall, who won a number of awards for his books including *The Machine Gunners*, has his full writing archive deposited in Newcastle at the Seven Stories centre.

Westgate

The Westgate was built around 1300 and demolished in 1824. The nearby gallows outside the Westgate were used by prisoners from Northumberland who had been held in the castle keep. They were last used in 1805 when Thomas Clare was hung there before they were finally removed in 1811. The last person to be hung in public in Newcastle was George Vass in 1863 at the gaol in Carliol Square and the last person to be hung in Newcastle gaol was Ambrose Quinn in 1919, six years before the prison closed.

Westgate Road

Westgate Road follows the line of Hadrian's Wall and remains of the wall have been found on the south side of the road at the Mining Institute, as well as a milecastle at the Newcastle Arts Centre. The name originated from the West Gate through which the road passed to enter the town. The West Gate was demolished to improve traffic flows into Newcastle.

Whately, Kevin

Kevin Whately from nearby Hexham found fame in *Auf Wiedersehen, Pet* as a Geordie bricklayer. He then continued his television career in *Morse* as assistant to the inspector before taking the leading role in *Lewis*.

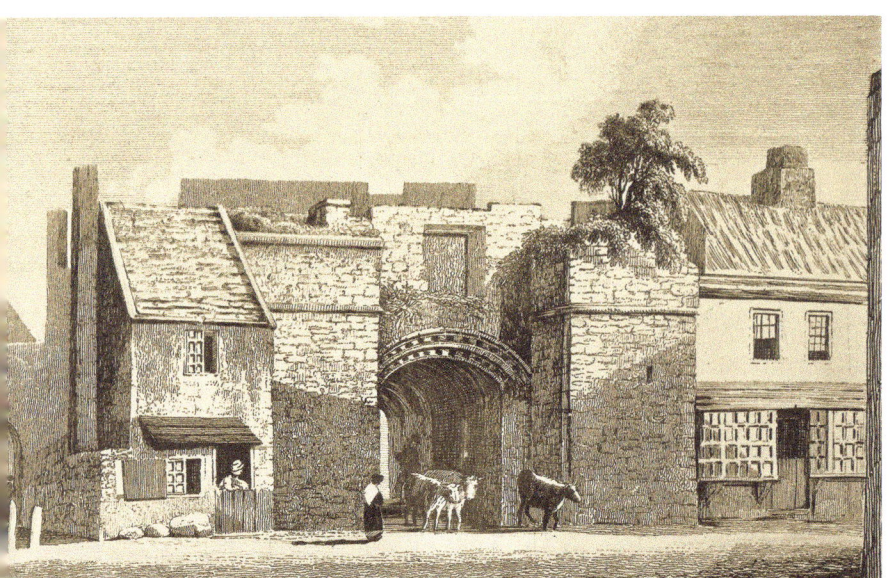

Westgate *c.* 1786.

W

Willington Waggonway

Discovered in 2013 on the boundary of Newcastle and Wallsend, the Willington Waggonway is the earliest railway discovered to date to have the standard railway gauge of 4 foot 8.5 inches. This remarkably well-preserved internationally important wooden waggonway was found under a former shipyard building. It was revealed during archaeological excavations, in advance of building works, while looking for Roman remains close to the line of Hadrian's Wall. The site also revealed the only wheel wash pond ever found beside the main track of a waggonway. The site was fully excavated and recorded before many of the unique wooden rails were removed for preservation and to be displayed later in the nearby Stephenson Museum in Wallsend. George Stephenson later used this size of track on the nearby Killingworth Waggonway to develop his locomotives including *Rocket*.

Wilson, Joe

The famous nineteenth-century Newcastle songwriter was born in Stowell Street and lived from 1841 to 1875. He wrote hundreds of songs including 'Keep Your Feet Still Geordie Hinny' and they were performed all over the North in music and concert halls. He briefly ran a Newcastle pub but he preferred performing on stage. He developed tuberculosis, an illness that ended his short life, and was buried in Jesmond Old Cemetery.

Windows

Hidden inside the Central Arcade but well known to all music lovers, the famous J. G. Windows shop sells everything from grand pianos to penny whistles. It has always sold the latest music recordings in all formats from records, cassettes, CDs, DVDs and MP3 players. It was established in 1908 and is one of the UK's oldest music stores as well as one of the region's biggest music shops.

Wylie, Graham Foundation

The founder of the Newcastle-based software company Sage, Graham Wylie set up the charity the Graham Wylie Foundation in 2016 to help sick children and their families. The millionaire businessman has raised hundreds of thousands of pounds himself for charity as a thank you to the medical team at the Freeman Hospital in Newcastle who saved his young daughter's life by performing open-heart surgery on her shortly after she was born.

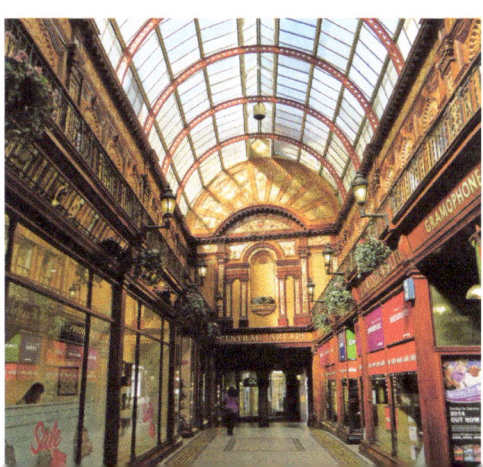

Windows, Central Arcade.

X

X Factor

Cheryl (Tweedy, Cole, Ferandez-Versini), the famous *X-Factor* judge who came to fame through Girls Aloud, comes from the Heaton area of Newcastle. She has not forgotten her roots and has linked up with the Price's Trust to open a new £2 million Cheryl's Trust Centre in Newcastle to help disadvantaged young people. She officially opened the centre on 20 February 2018 saying how proud she was of Newcastle: 'it's the heart of me'. See also Joe McElderry, winner in 2009.

Xisco (Francisco Jiminez Tejada)

Xisco was a Spanish footballer who rarely played for Newcastle from 2008 to 2013 and who cost £5.7 million. He only played eleven games and scored one lucky goal and was loaned out for long periods. He is remembered as one of the flops who led to Kevin Keegan ending his second period as manager after Francisco Jiminez Tejada, or Xisco, was signed by others who did not consult Keegan first.

Xander

Alexander Henry Fenwick Armstrong of *Pointless* fame was born in Rothbury and knows Newcastle well. He was appointed president of the Lit & Phil in 2011 and also received an honorary degree from Northumbria University in 2015.

X Marks the Spot (Theatre Royal)

On the pavement outside the Theatre Royal on Grey Street is a carved X in a paving stone. This marks the spot where a time capsule was buried by local school children in 2000 as part of street improvements linked to the Grainger Town Project.

X marks the spot.

Y

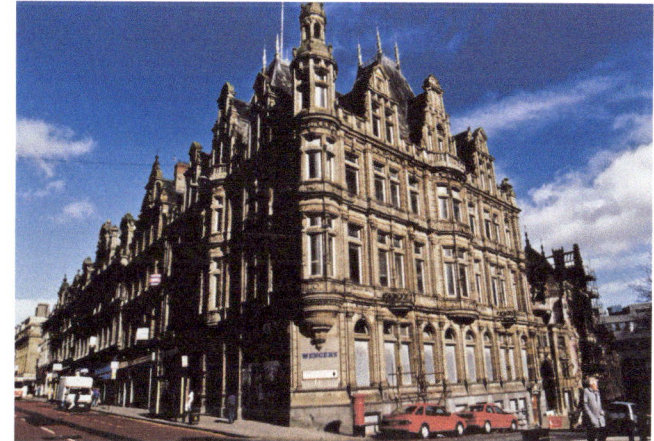

Yates, former Wengers Store, Grainger Street, c. 1980.

Yates

Yates pub and restaurant on Grainger Street occupies the building formerly used by Wengers Department Store from the 1960s to 1984. It was originally built in 1887 for Newcastle & Gateshead Gas Co. and still has a gas flame sculpture on the domed roof.

YMCA

The Young Men's Christian Association building was a landmark building in Newcastle for years standing on the corner of Blackett Street and Grainger Street overlooking Grey's Monument. It was built on the site of St James' Chapel in 1885 and was demolished in the 1970s to be replaced by Eldon Square shopping centre.

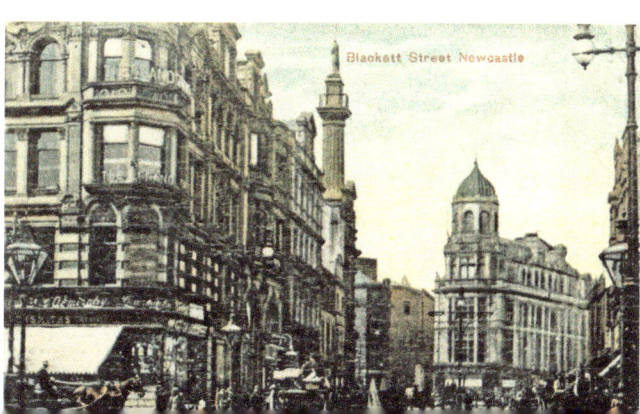

YMCA, Blackett Street, c. 1905.

Zamyatin, Yevgeni

Yevgeni Zamyatin (1884–1937) was a Russian naval architect, novelist and playwright. He came to Newcastle from 1916 to 1917 to oversee the building of two ice breakers (*Sviatogor* and *Saint Alexander Nevski*) at a Tyneside shipyard. He lived in Jesmond and later featured the people of Jesmond in his writing – and not in a complementary way. He wrote a book in 1917 called *We* where the people were given numbers instead of names and their lives were ordered and controlled totally by the authorities who watched over them as they lived in see through houses within a glass dome. This book has been said to be the inspiration for books such as *Nineteen Eighty Four* by George Orwell and *Brave New World* by Aldous Huxley.

Zoology Degree, Newcastle University

Newcastle University has a well-established School of Biology and Zoology, which offers degrees in zoology and related subjects.

Zoo

For a number of years in the 1960s Newcastle had a Winter Zoo based in the old Town Hall in Bigg Market. The animals on show featured giraffes, elephants, tigers, lions, monkeys, snakes and llamas, many of which were on loan from Flamingo Park in Yorkshire.

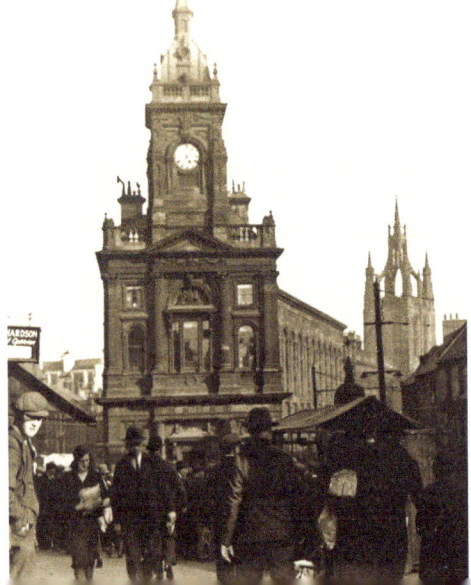

Zoo was held in the old Town Hall Bigg Market, seen here *c.* 1940.